graphic

from woodblock and zen
to manga and kawaii

natalie avella

RotoVision

A RotoVision Book

Published and distributed by RotoVision SA
Route Suisse 9
CH-1295 Mies
Switzerland

RotoVision SA
Sales & Editorial Office
Sheridan House
112/116A Western Road
Hove BN3 1DD
United Kingdom

phone +44 (0)1273 72 72 68
fax +44 (0)1273 72 72 69
email sales@rotovision.com
web www.rotovision.com

10 9 8 7 6 5 4 3 2 1

ISBN 2-88046-771-3

project management Nicola Hodgson
art direction Violetta Boxill + Luke Herriott
design Alexander Boxill

Reprographics in Singapore by ProVision Pte.
phone +65 6334 7720
fax +65 6334 7721

Printing and binding in China by Midas

a symbol indicates a cross-reference to an example
of the cited designer's work in the gallery section:
✿ = gallery 1
✳ = gallery 2

introduction

Japan's vibrant visual culture has long intrigued graphic designers worldwide, and today its design output continues to be as prolific and groundbreaking as ever. *Graphic Japan* collates new, innovative work from up-and-coming Japanese designers, as well as recent work from established studios. Collected in these pages is a diverse range of inspirational and thought-provoking imagery, including posters, packaging, typography, signage, editorial design, CD covers, and corporate identities.

Graphic Japan examines the cultural and economic influences that are propelling a new wave of graphic designers. As well as looking at new trends such as *manga* and *kawaii*-influenced design, *Graphic Japan* studies traditional influences—such as the themes of simplicity and emptiness inspired by Zen Buddhism—reflecting the unique personality of Japan, a country that manages to fuse nostalgia with constant reinvention like nowhere else in the world.

the design scene in japan

more than graphic
design: moving beyond
two dimensions

introduction 5

Many Japanese creative industries are based around fashionable southwest central Tokyo, circling Shibuya. Over the last 30 years, these areas, which include Harajuku, Omotesando, Daikanyama, and Aoyama, have grown to become the hotbed of Japanese trends. The headquarters of contemporary Japanese fashion houses, including Issey Miyake, Yohji Yamamoto, Comme des Garçons (Rei Kawakubo), Kenzo, and Koshino Junko, have long been established in Aoyama. Since the early 1990s, the big names in European luxury goods, such as Gucci, Missoni, Chanel, and Christian Dior, have set up camp in Omotesando. It is also in this area that many of Japan's top graphic design studios are based.

Apart from the rituals of removing your shoes at the entrance and exchanging business cards (accept with both hands, pause to admire, and then lay it on the table before you), walking into a design studio in Japan is like entering one anywhere in the world. Most studios are a unique expression of the designer's personality or working practice, and their studio interiors are consequently diverse.

Design studio Graph (see pages ✿ 36–41, ✱ 128–129, ✱ 152, ✱ 174–175, ✱ 183, and ✱ 195) is a shrine to minimalism. The airy space has white walls, the palest of carpets, and not a single pot of pens, notepad, or Post-it note to clutter the stark, bare desks.

This is the polar opposite of the temple of kitsch belonging to Butterfly Stroke Inc. (✿ see pages 18–25, ✱ 194, ✱ 196–200, and ✱ 202–203), which is full of lifesize cartoon figurines and gadgets fighting for space.

There is no room for toys in the compact space inhabited by design agency Nomade (✿ see pages 52–57), but step onto the huge roof terrace and you are presented with a stunning view of the Shinjuku skyline. This district of soaring skyscrapers and seedy shopping streets was said to be the visual inspiration for Ridley Scott's iconic 1980s sci-fi movie *Bladerunner*.

In contrast to Nomade's small room, design agency Draft is based in a beautiful modern mansion with a sweeping art deco-style staircase leading up to a boardroom with plush chairs, overlooking a peaceful garden with ornate trees and a pool.

Something that struck me about almost all the designers I met while researching this book was their refusal to be pigeonholed as graphic designers alone. Although many were established within the Japanese graphic design industry, there seemed to be a widespread enthusiasm for branching out from two-dimensional work and getting involved in architecture, product design, printing, and other related—or even completely unrelated—industries. In a country not always known for its non-conformity, such daring and innovation seems contrary to perceived stereotypes.

One company that embraces this spirit of risk-taking and diversity is Curiosity (✱ see pages 154–159). Headed by husband-and-wife duo Gwenael Nicolas (who hails from France) and Reiko Miyamoto, this team works not only on graphic design, but on architecture, interiors, furniture, products, and packaging. Even their graphic design seeks to transcend two-dimensionality. A children's book that they designed for artist Takashi Murakami (✱ see page 194) is a waist-high, almost sculptural, structure, while their design for an invitation to the opening of the new Louis Vuitton shop in Omotesando was engraved in large blocks of glass.

Draft, set up in 1978, for a long time concentrated on advertising art. Then founder Satoru Miyata (who had never been a conformist) decided to become a baker.

more than graphic
design, moving beyond
two dimensions

After branching into product design through sister company D-BROS, Miyata started a bakery combined with a café and product shop in order to probe the fusion between business management and design. Yoshie Watanabe and Ryosuke Uehara are the main creative brains behind D-BROS, designing beautiful products such as cups and saucers, vases, books, and greeting cards that feature quirky paper engineering (✿ see pages 50–51 and ✳ 160–173).

Graph's Issay Kitagawa (see pages ✿ 36–41, ✳ 128–129, ✳ 152, ✳ 174–175, ✳ 183, and ✳ 195) runs not just a graphic design agency but a printing company too. The success of Kitagawa's graphic design is often inextricable from the innovation of the printing process, the ink, and the texture of the paper that he combines with it. There is no hierarchy between the design, paper, ink, and printing process used—all are purposely fused to form an experience that is both visual and tactile. Often, the result of this combination has a limited-edition effect, with each sheet made to look as though it has been individually hand-printed. Kitagawa likes to play with ambiguity; his bold intention is that the hand-crafted look and feel of his design confuse people into thinking that it may be the work of an amateur.

Yasushi Fujimoto runs design agency Cap and is also one of Tokyo's best-known editorial designers. He is renowned for his work on *Studio Voice*, as well as on *Vogue Nippon*, *Brutus*, *Casa*, and *Olive*. He also runs an art gallery called Rocket. The gallery, based a stone's throw from Omotesando, is on the top floor of a two-level building. On the bottom floor is the Rocket store, a place where, Fujimoto says, "People can buy artworks just like when they shop for fashion and interior goods." The artwork includes the work of many graphic designers and illustrators.

In 2003, Rocket Gallery held an exhibition by graphic designer Jonathan Barnbrook, who, although based in London, has many clients in Japan. In 2003 he won an international competition to design the corporate identity for Roppongi Hills (✳ see pages 122–125), the largest post-war development in Tokyo. This is a five-billion-dollar project that includes a 58-story tower, a 390-room Grand Hyatt Hotel, a television broadcasting headquarters, a performing arts center, residential buildings, a school, shops, and restaurants. The 49th floor of the tallest tower houses the Mori Art Center, an institution affiliated with the Museum of Modern Art in New York, whose logo Barnbrook also designed. Artist Takashi Murakami (✳ see page 194) and one of Tokyo's leading illustration groups, Enlightenment (✳ see pages 192–193 and ✳ 201), also contributed to the graphic image of the Roppongi Hills complex.

Barnbrook's designs have proved so popular in Japan that in 2004 there was a retrospective of his work at the Ginza Graphic Gallery (GGG), an influential gallery devoted to exhibiting and promoting graphic design. The gallery is based in Tokyo's Ginza area, once home to Japan's newspaper and printing industry, and stands on what was once the factory of Dai Nippon Printing Co. Ltd (DNP). When the company moved in 1986, it decided to keep the space and open it to the public as a gallery to "penetrate the general interest in graphic works."

GGG is the sort of gallery—focusing exclusively on graphic and advertising art—that every city needs, but that most, unfortunately, lack. Each month, an exhibition focuses on a different designer or design theme. As well as holding retrospectives of established designers' work, the gallery puts on an annual exhibition called *Graphic Wave* in which it introduces three young up-and-coming designers. In 2003 it featured the work of the young female designer Nagi Noda, whose humorous work depicting otherworldly scenarios has taken the design world by storm (✿ see pages 26–35 and ✳ 190–191). The gallery also hosts talks and lectures and publishes beautifully produced books focusing on the work of individual designers. DNP has since opened other graphic art galleries in Dojima, Osaka, and Sukagawa.

It is clear that Japanese graphic designers are curious about and aware of what is happening in the international design community. They are certainly more aware of what is happening outside their own country than many Westerners are aware of what is happening in Japan. This book seeks to redress the balance and introduce the wider international community to the graphic language of Japan.

The Ginza Graphic Gallery is a great place for visitors to Japan to find out more about the design scene. For those outside Japan wishing to keep their eye on latest developments, the web-based magazine *Shift* (http://www.shift.jp.org), which has been online since 1996, is a good place to start. *Shift* invites a different Japanese or international designer to contribute to the on-screen graphics each month, thereby retaining a fresh visual style and sense of playfulness. With 1.5 million hits a month, *Shift* is perhaps one of the most popular design-related web magazines. The team behind *Shift* also runs a gallery/café/restaurant in its home city of Sapporo in northern Japan.

IDEA, a long-established print-based magazine in Japan, is a good source of information on current Japanese graphic design. It is bilingual (English/Japanese) and available in most international design bookshops. Each issue contains a special profile on a graphic designer, and this designer is given free rein to design a number of pages as he or she wishes. Other good bilingual sources include GAS DVDs and *Atmosphere* magazine, which is published by Design Exchange Co. Ltd. This company also publishes books featuring retrospectives of works by contemporary designers in the fields of graphic design and moving image. Recent publications have focused on both Japanese and international designers, including the USA's Geoff McFetridge and Mike Mills; the UK's Big Active, Tomato, and Why Not Associates; and France's Elisabeth Arkhipoff + Laurent Fetis. Design Exchange Co. Ltd also runs a concept shop, GAS SHOP, in Nakameguro, Tokyo. This sells their publications as well as specially commissioned merchandise such as clothes and products designed by graphic artists and illustrators. The small shop is an Aladdin's cave for design fetishists, and certainly somewhere for graphic designers to put on a "must do" list when visiting Tokyo.

japan's
influence on
modern design

There is a tendency in the West to think of Japanese contemporary design as being directly influenced by Western aesthetics and values. While it is true to say that the Japanese are fascinated by whatever is new and groundbreaking in Western design, and that Japanese work often incorporates Western motifs (including English text and Caucasian models), the best European and American design of the past 140 years or so would not have existed as we know it were it not for the influence of Japanese culture and aesthetics.

Most people in the West first became aware of Japanese art in the 1860s, following the opening of trade routes with Japan in 1853. Japanese arts and crafts were introduced to Europeans and Americans at the *World Exhibitions* that were held every few years in the major Western cities. London's pioneering *International Exhibition* of 1862 was followed by the *Exposition Universelle* in Paris in 1867, which ignited a "Japan boom," and by the *Philadelphia Centennial Exhibition* in 1876. Thousands of items, such as weapons, books, paintings, prints, musical instruments, lacquer work, ceramics, metal works, paper samples, and textiles, were shown in the exhibitions.

Japanese objects became the fad, and one that artists took up with particular enthusiasm. For a time, Japanese fans, sliding screens, and porcelain were popular props in artists' studios, and models were painted dressed up in kimonos. This enthusiasm for all things Japanese is known by art historians as *japonaiserie*. This is quite distinct from *japonisme*, a term coined in 1872 by the French critic and collector Philippe Burty, which describes the elements of Japanese art that influenced, and were integrated into, Western art.

One of the most influential of the Japanese arts was *ukiyo-e*. *Ukiyo-e* is the general term for a genre of Japanese woodblock prints produced between the seventeenth and twentieth centuries. *Ukiyo-e* literally means "pictures of the floating world." The term refers to a time prior to the mid-1800s when Japan was isolated from the rest of the world and was run by the *shogun*—military dictators who forbad travel overseas. The imagery featured in these woodblock prints is often closely connected with the metropolitan pleasures of theaters, geisha, and teahouses, although many also depict tranquil scenes from nature—including images that have almost become clichés, such as views of Mount Fuji and depictions of cherry blossoms.

These woodblock prints have several distinctive features that seemed unusual and unexpected to Western eyes in the nineteenth century. *Ukiyo-e* used solid areas of color; strong contour lines; decorative shapes; and little, if any, chiaroscuro (shading or modeling), resulting in a conception of space and mass that emphasized two-dimensional qualities. These flat and linear depictions disregarded the mathematical perspective that was faithfully adhered to in Western aesthetic systems.

An essential part of the Japanese aesthetic is unornamented surfaces, something that features strongly in *ukiyo-e*.

Even as far back as twelfth-century narrative scrolls, large parts of the scroll were left blank, as plain surfaces are valued as highly as patterned ones. This trait extends to all Japanese art; for instance, the silences in classical Japanese music are thought to be as important as the notes played—"quiet" space provides a balance to "noisy" ornament.

Another feature of *ukiyo-e* that surprised Westerners viewing Japanese woodblock art was the cropping: edges of pictures are cut in unexpected ways, often slicing through a subject, so that it appears to loom out of the frame in an energetic and dynamic way. Figures are seen from behind, in shadow, or partially obscured. Like the use of blank space, unusual angles and viewpoints did not emerge in *ukiyo-e* prints but had existed throughout the history of Japanese art. A style called "cutaway" painting is seen in narrative scrolls painted by court women in the twelfth century. The viewer of these "cutaway" works looks down into the interior of a house or room from which the roof has been removed.

The Japanese woodblock art presented at major international exhibitions in the late nineteenth century presented visual imagery that had never been seen before in the West and caused quite a sensation. This 1901 description from *The Process Yearbook*, a yearbook newly launched in England to introduce printers to the new printing processes of the time, explains why Westerners found it difficult to understand Japanese visual culture:

"It is not easy at first, because it defies every law in which we have been carefully brought up. The great aim of European artists for centuries has been so to treat a flat surface that it may not look flat any longer, that it will deceive the spectator into the idea that he is looking through a pane of glass into a hole in the wall. The owner of a new Academy picture likes to hang it on the wall with a feeling that he has a new window in his room, whence he can look straight away into a bit of Venice or Switzerland, and he likes to see a long way from its foreground to its middle distance, and from the middle distance to the vanishing greys of its horizon. Now the Japanese artist goes to work quite differently. Modelling and chiaroscuro are nothing at all to him. He does not for one moment wish to pretend that the paper he works on is anything else but flat. He takes no trouble to deceive the eye with contours. His first aim is to decorate that piece of paper beautifully, and next, without imitating the things he draws, to give them essential reality. For while he never imitates, he is a wonderful realist. With marvellous energy and power he seizes the very essence of what he wishes to portray, grips it intensely and allows nothing of its vivid and life-like qualities to escape him." [1]

When Western artists such as Whistler, Manet, and Van Gogh started to adopt aesthetic elements used in Japanese art, the effect proved to be sensational. These painters cast aside techniques that Western artists had previously used to create the illusion of three-dimensional space and mass, and experimented with the Japanese emphasis on contour and outline, the use of blank spaces, flat-color tones, repetition, and simplification. Whistler and Toulouse-Lautrec were particularly intrigued by the Japanese way of cropping figures, and Toulouse-Lautrec become renowned for his paintings and prints of cabaret artists on stage, seen from dramatic and unusual angles not previously used in Western art.

The Japanese aesthetic had a profound effect on the new industries of advertising and graphic design, which started to emerge from 1860 onward, thanks to advancements in printing techniques, particularly lithography. Although lithography had been invented at the end of the eighteenth century, it was not until the end of the nineteenth century that color was introduced. These developments allowed artists to print large (Japanese-inspired), solid areas of color and gave them the freedom to draw their own lettering, which had previously been limited to a restricted range of ready-made type designs.

Advancements in printing technology made the mass duplication of posters possible. This was important because the color posters that were displayed on the streets of Western cities were the most powerful medium for communication before advancements in other media, such as the growth of the magazine industry, provided alternative space for advertising.

Toulouse-Lautrec and Jules Chéret were the first practitioners of what we know as "graphic design" today. Both used the *japoniste* elements of solid-color background, cut-off figures, and unusual viewpoints. Chéret is the undisputed father of the modern poster in the West. He introduced vivid, direct designs, combining illustration and text, and the use of a few bright colors in large coherent shapes. In America, poster artist Will Bradley also absorbed the Japanese and *japoniste* aesthetic that had first filtered through from Europe.

These artists helped to elevate the status of the poster to a higher art form. The 1880s and 1890s marked the beginning of *L'Affichomanie*—the poster craze. In Europe, colorful, large billboard works by Toulouse-Lautrec, Chéret, and others, were viewed as public works of art.

The Japanese influence on Western art and design today is so pervasive and so deeply ingrained within Western art traditions that one simply no longer sees common themes, motifs, and techniques as being specifically Japanese. Many academics and art historians believe that Western modernism would not have happened were it not for the Japanese influence. This influence extends not just to pictorial art but to all the arts, including literature, theater, architecture, ceramics, and textiles.

japanese
poster design

The poster-mania that hit Europe and America in the 1880s and 1890s soon caught on in Japan. As woodblock printing was replaced with modern lithography, there was greater demand for designed printed material. Prior to this period, advertisements were either individually painted on cloth or printed on paper.

Early advertising posters in Japan aped the European style, grossly regurgitating their culture's own influence, and never achieving the same iconic status in the global history of art. As Richard S. Thornton explains in his book on the history of Japanese graphic design:

"Poster design suffered from a confusion of identity. Artists replaced feudal motifs with pseudo-Western images in garish colors which lacked Japanese spirit. They could not decide whether they should continue with traditional imagery and remain provincial, or adopt Western views to show how international the country could be. The public chose the international image." [2]

It was not until after World War II that the first masters of Japanese poster design emerged. These designers successfully blended new Western influences with a Japanese sensibility. Following the war, Japanese designers made an effort to gain international recognition for their work and established prestigious members groups such as the Tokyo Art Directors' Club, Tokyo Type

Directors' Club, and the Japanese Association of Graphic Designers (JAGDA), which all still exist today.

Kazumasa Nagai, Tadanori Yokoo, and Ikko Tanaka (see page 100) are perhaps the most internationally renowned of these designers. All three successfully forged the old with the new to come up with iconic and universally appealing, yet somehow pastiche-free, images. Tanaka is widely thought of as the father of Japanese graphic design, and influenced designers both in Japan and overseas. Thornton explains Tanaka's appeal:

"Tanaka's popularity in the United States and Europe can be attributed to his ability to provide Japanese graphic images most appreciated and expected by foreigners. His work is almost an exploitation of traditional Japanese images—masks, *ukiyo-e* prints, *rimpa* motifs, calligraphy and Japanese colour. He is recognized for his Kanze Noh Theatre posters, produced between 1953 and 1974, in which he mixes modern European design principles with traditional imagery. He walks a fine line in his Noh posters, carefully legitimizing Japanese souvenir-style visual clichés with a modern adaptation of colour, technical manipuation and focus." [3]

Throughout much of the twentieth century, posters served as a major advertising medium in Japan. All the great graphic designers made their names through poster art. In the last couple of decades, a proliferation of alternative media means that posters are not as ubiquitous as they once were. National competitions continue to champion the relevance of poster art, and many designers fund their own entries with work that is not client-commissioned (although there are signs that even the amount of artists' own work entered into competitions is diminishing). The older generation complains of a lack of creativity in new poster design, suggesting that computers make everything look the same. Some younger designers dispute this criticism, arguing that the greatest posters were produced when Japan was wealthy, when budgets were open, and when campaigns had two years to prove themselves instead of the three months that they get today.

In one interview, Kazumasa Nagai, who continues to influence new generations of graphic designers, defended the poster above all other media:

"There have been a number of discussions on the decline of the poster as a means of expression, but we should not dismiss the long tradition of posters since the era of Lautrec and Cassandre. It has remained valid because the poster is, after all, a medium with which a designer can apply and exercise all his ability. A poster is a part of an advertisement; however, it obviously has less restriction than newspaper ads. It also has a more picturesque character and conveys an instant visual communication with the viewer. I believe that this speed of communication is still up-to-date. Posters also look more impressive than small newspaper ads when exhibited. Design should not only value its economic asset but also its relation to culture and society. In this case, posters can be an important field of expression for designers." [4]

Nagai does not dismiss the new generations of Japanese graphic designers. He points out strong work by younger designers such as Kenya Hara's designs for Muji (✿ see pages 88–95) and Nagi Noda's designs for Laforet (✿ see pages 30–33).

east vs west: ambiguity and clarity in contemporary design

Although *japonisme* still pervades Western aesthetics, many Westerners find Japanese design very abstract. It does not always present the viewer with an accurate representation of form or object; colors are exaggerated or eliminated; an object is reduced to its barest elements; any superfluous detail is discounted; and text is minimal or stripped out completely. Some Western viewers therefore struggle to understand Japanese design, as graphic designer Noriyuki Tanaka (✿ see pages 68–69) comments:

"Japanese graphic design communication has a tendency to work in similes and vague nuances, but Japan is also formed of a comparatively unified language and ethnic group, so if there's no twist to it, no complexity, then there's no impact. On the other hand, clear communication is valued for graphic design in the United States, because the US is a multicultural nation. At international competitions, people often say they don't really understand Japanese graphic designs, or that they don't work as communication, but it's also true that this tendency to simile gives Japanese graphic design power." [5]

This difference between US and Japanese designers was apparent during a recent Icograda (International Council of Graphic Designers) congress in Nagoya, Japan, in the way each nationality described how they used design to communicate. The Japanese designers spoke about emotion, beauty, and the need to make the familiar unfamiliar to the end viewer. The Americans spoke about their approach to design being based on rationality and attempts to make the unfamiliar as familiar as possible. Japanese designers focus on engaging the user of the information in new ways of thinking, whereas the Americans try to remove ambiguity and abstraction. Both groups are keen on simplicity, although this means different things to each. For Americans, simplicity means presenting information with clarity. To the Japanese, simplicity means a sparse aesthetic purity that eliminates superfluous detail, and even informational clarity, so the viewer has to seek out the message in the design in the way they would with a piece of art. This is not to say, of course, that American graphic design is not cerebral, emotional, or beautiful, or that Japanese graphic design lacks clarity. There are plenty of exceptions.

As Noriyuki Tanaka suggests (left), Japanese graphic designers may be able to get away with more abstraction than their American counterparts can because Japan is a much smaller country and has a much more homogeneous population when compared to the United States.

The United States is home to many large cultural groups (Jewish, African American, Hispanic, Native American, etc.), who, with their myriad of religions, belief systems, and customs, possess a very limited "shared" cultural heritage. American designers need to modify messages so that they can reach a specific minority or be accessible cross-culturally. Japanese people have a long shared history and therefore possess long-established common cultural references. For instance, almost all Japanese people follow the indigenous religion Shinto, and, of these, more than two-thirds also practice Buddhism. Shinto does not have one all-powerful deity, enabling it to be combined with other religions. Shinto gods, or *kami*, are spirits that are thought to be present in natural phenomena such as mountains, trees, waterfalls, strangely shaped rocks, and even sounds. For many centuries, Japanese aesthetics have been influenced by Shinto's devotion to nature and by Buddhism's expressions of humility and simplicity as a way to reach enlightenment.

This dual influence pervades Japanese style not only in art and design, but architecture, ceramics, flower-arranging (ikebana), fashion, music, and theater. Simplicity through abstraction has for a long time been a common tool for communicating. It is not a new way of thinking for the Japanese. Because of these shared cultural "givens," Japanese designers can extend and add twists to the abstraction and remain confident that they will still be understood. To the average Japanese person, abstraction is a common way of thinking and communicating.

For an example of the inability of Westerners to understand Japanese aesthetics, here is a comment from British journalist Lynn Barber in a travel article about Tokyo:

"Our tea ceremony lasted an hour and felt like a decade. It gave new meaning to the term boredom. But a real tea ceremony lasts four hours—four hours of kneeling on tatami mats, not speaking (only the main guest is allowed to speak to the host and no one is allowed to speak to the Tea Master) with only two cups of tea—one thick, one thin—and two red bean sweets by way of reward. If this is the traditional Japanese idea of fun, no wonder the young are so enchanted by Western culture." [6]

Maybe there is some truth in this. The brashness and irreverence of the West certainly has had some appeal to young Japanese designers (as it appealed also to post-war designers who were keen to accept the new democratic freedom the West had imposed). Yet it seems, from some of the work collected in this book, that they absorb certain visual elements of the West into their design rather than discarding their own culturally innate ways of communicating. These innate ways of communicating are looked at closely in the next chapter.

1. Charles Dawson (1901) "Japan and its colour prints." *The Process Yearbook* p96. Bradford, England: Percy, Lund & Humphries.
2. Richard S. Thornton (1991) *Japanese Graphic Design* p35. London: Laurence King Ltd.
3. Thornton, *ibid.* p108.
4. Kazumasa Nagai (2003) "My involvement with posters." *IDEA* issue 300.
5. Noriyuki Tanaka in discussion with Hiroki Azuma and Kei Matsushita (2003), *IDEA* issue 300.
6. Lynn Barber "Thanks for all the fish." *Observer Travel Magazine*, Winter 2004, issue 3 p45.

✿ see page 5
below, right + far right
promotional posters
design agency: Butterfly
Stroke Inc.
client: Laforet
art director: Katsunori Aoki
computer graphics: Ichiro
Tanida

Robotic women symbolize
shoppers about to spat for
bargains, in these posters
for teen paradise department
store Laforet, a store with
hundreds of small clothing
boutiques filled with
eccentric fashion.

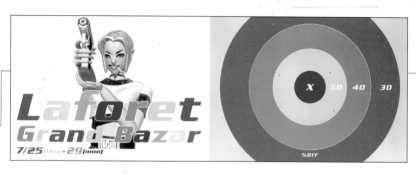

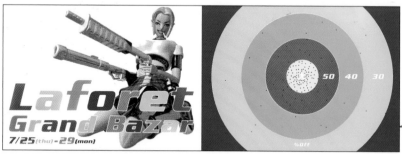

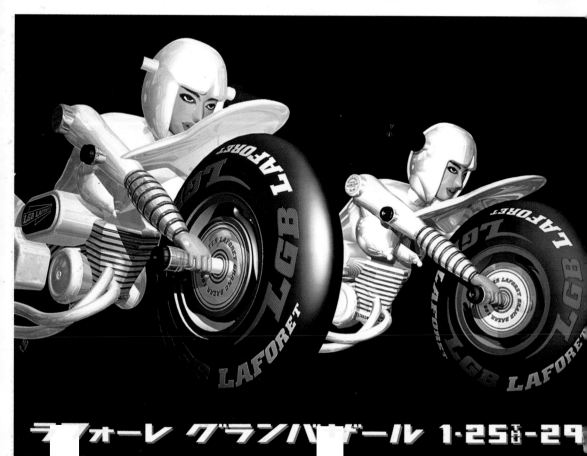

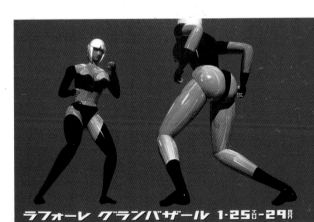

✿ see page 5
right + below
promotional posters
design agency: Butterfly
Stroke Inc.
client: Laforet
art director: Katsunori Aoki
designers: Katsunori Aoki,
Ichiro Tanida, Yasuhiko
Sakura
computer graphics: Ichiro
Tanida

Colorful scribbled lines
create these characters,
which seem to be cheering
the opening of the Laforet
summer sale.

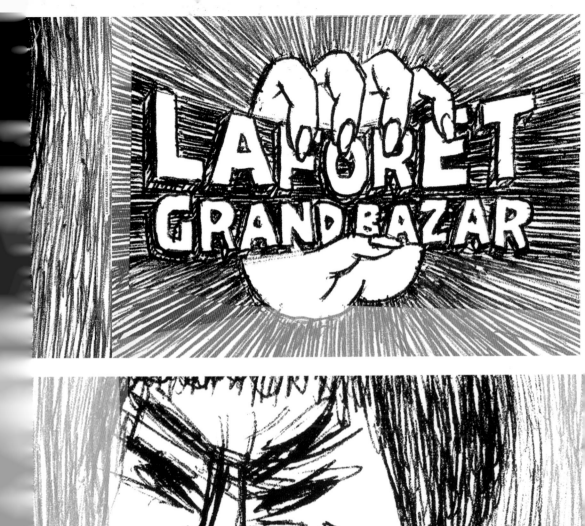

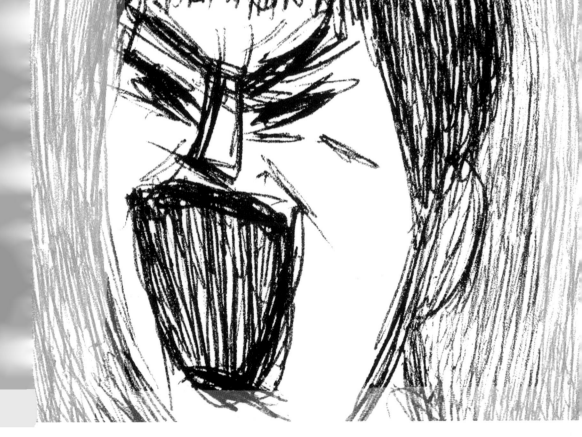

✿ see page 5
below
promotional posters
design agency: Butterfly
Stroke Inc.
client: Fields Corporation
art director: Katsunori Aoki
designers: Katsunori Aoki,
Kana Takakuwa
illustrator: Isao Makino

These simple, "doodly,"
illustrations for Fields,
a company that markets
pachinco (vertical pinball)
machines, are quirkily at
odds with the garish, neon-
lit *pachinco* halls that are
an integral part of the
Japanese cityscape.

✿ see page 5
right
design competition poster
design agency: Butterfly
Stroke Inc.
client: Fields Corporation
art director: Katsunori Aoki
designers: Katsunori Aoki,
Kana Takakuwa
illustrator: Bunpei Yorifuji

To generate ideas for
creating new *pachinco*
hall experiences, Fields
launched a *pachinco* hall
design competition.
Butterfly Stroke Inc.'s entry,
shown here, amusingly
touches upon every
"theme-park" possibility.

The Greatest Leisure
For All People.
Fields
Gaming and Entertainment

The Greatest Leisure For All People.
Fields
Gaming and Entertainment

The Greatest Leisure For All People.
Fields
Gaming and Entertainment

PACHINCO HALL DESIGN COMPETITION

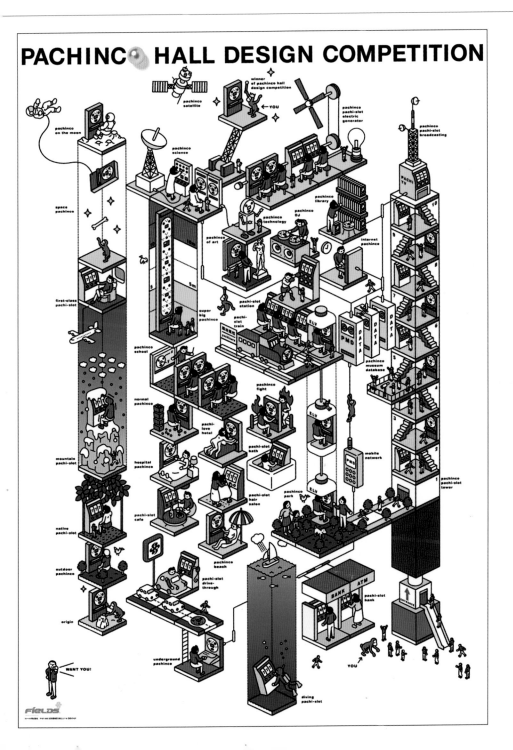

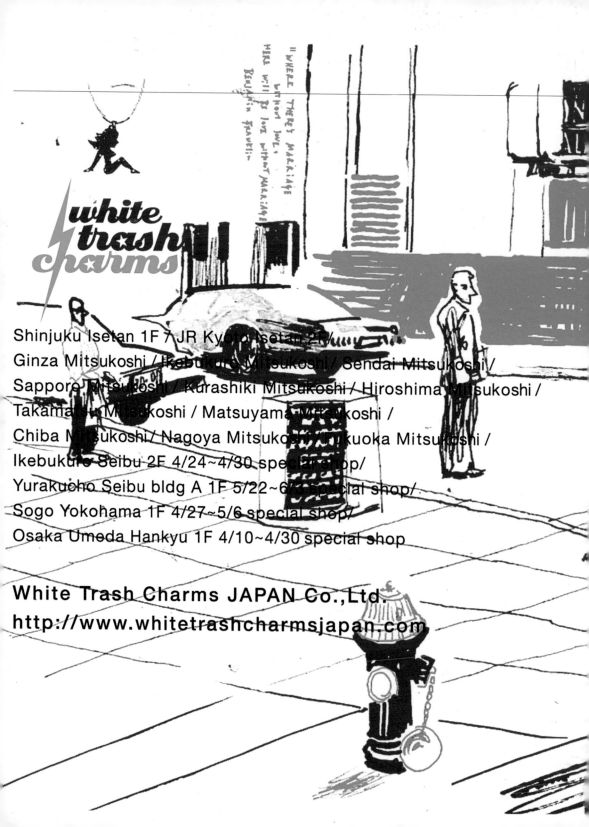

white trash charms

"WHERE THERE'S MARRIAGE
WITHOUT LOVE,
THERE WILL BE LOVE WITHOUT MARRIAGE"
Benjamin Franklin

Shinjuku Isetan 1F / JR Kyoto Isetan 2F/
Ginza Mitsukoshi / Ikebukuro Mitsukoshi/ Sendai Mitsukoshi /
Sapporo Mitsukoshi / Kurashiki Mitsukoshi / Hiroshima Mitsukoshi /
Takamatsu Mitsukoshi / Matsuyama Mitsukoshi /
Chiba Mitsukoshi/ Nagoya Mitsukoshi / Fukuoka Mitsukoshi /
Ikebukuro Seibu 2F 4/24~4/30 special shop/
Yurakucho Seibu bldg A 1F 5/22~6/3 special shop/
Sogo Yokohama 1F 4/27~5/6 special shop/
Osaka Umeda Hankyu 1F 4/10~4/30 special shop

White Trash Charms JAPAN Co.,Ltd.
http://www.whitetrashcharmsjapan.com

✿ see page 5
promotional poster
design agency: Butterfly
Stroke Inc.
client: White Trash Charms
JAPAN. Co
art director: Katsunori Aoki
designers: Katsunori Aoki,
Kana Takakuwa, Atsushi
Murata

White Trash Charms is an
accessories boutique selling
such wares as naked-lady
pendants and Playboy-
bunny charms. The odd
"Jews for Jesus" and
Benjamin Franklin quote
featured in the poster might
seem obscure to Western
eyes, to say the least.

✿ see pages 7 and 13
below + right
**Yuki posters: Stand up!
sister single
design agency: Uchu
Country Co. Ltd
client: Yuki/Sony Records
art director: Nagi Noda**

Animal illustrations create
typographic shapes in this
ad for pop singer Yuki.

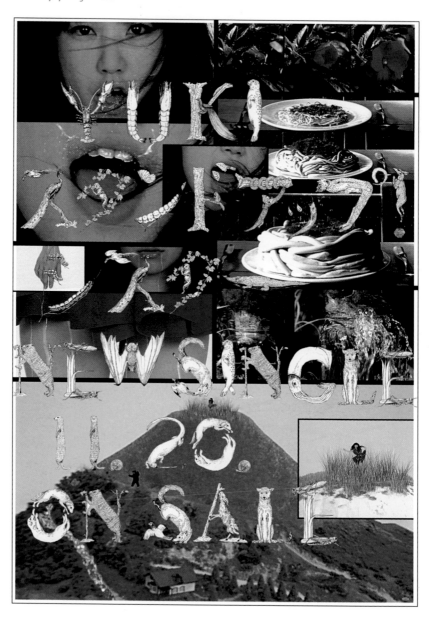

YUKI
スタンドアップ!
シスター

NEW SINGLE
11. 20.
ON SALE

✿ see pages 7 and 13 below

Yuki poster: Commune album
design agency: Uchu Country Co. Ltd.
client: Yuki/Sony
art director/designer: Nagi Noda

In this poster for Yuki's album *Commune*, the singer inhabits a surreal world in which she is multiplied, dies, and is lifted to heaven against a peculiar backdrop of golfers and giant birds.

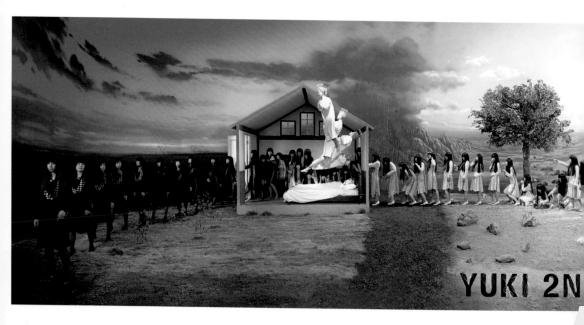

YUKI 2N

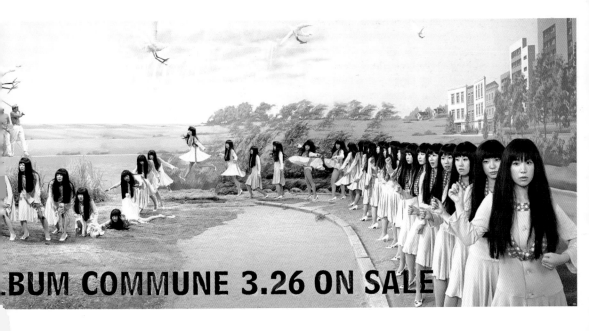

.BUM COMMUNE 3.26 ON SALE

✿ see pages 7 and 13
right + below
**promotional posters
design agency: Uchu
Country Co. Ltd
client: Laforet
art director/designer: Nagi
Noda**

In this sequence of posters,
Nagi Noda gives the viewer
a glimpse into bizarre and
otherworldly scenarios.
Girls in faded period
costumes tuck into an
unappetizing-looking dish,
while butterflies dance
around a young woman's
head, carrying her braids.

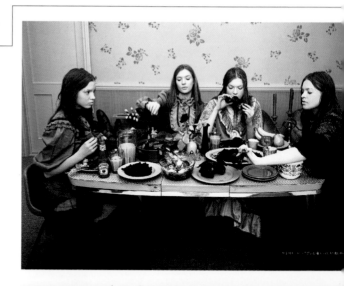

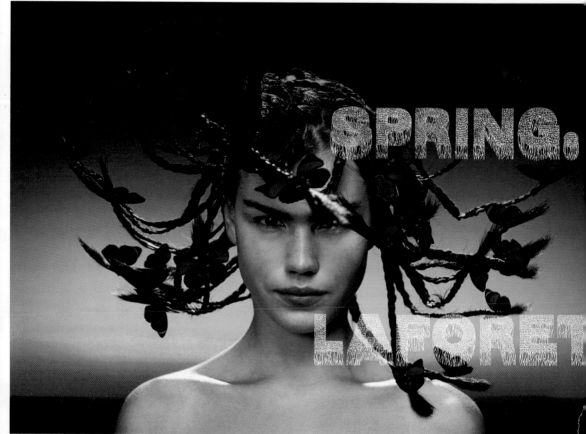

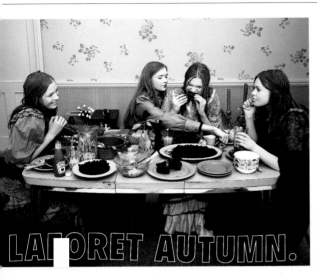

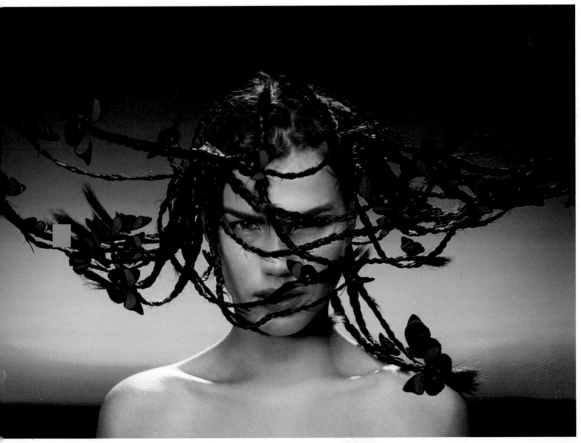

✿ see pages 7 and 13
right + below
promotional posters
design agency: Uchu
Country Co. Ltd
client: Laforet
art director/designer: Nagi
Noda

More quirky scenes from
Nagi Noda: a girl's giant
tongue whisks away plastic
bride and groom figures
from a miniature church,
and a woman gives birth
to a whole baby-shaped
troupe of figurines.

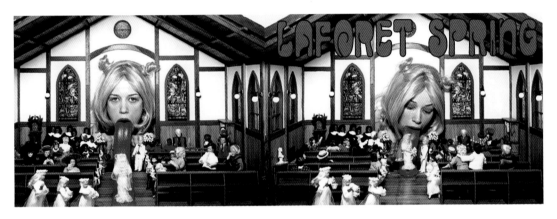

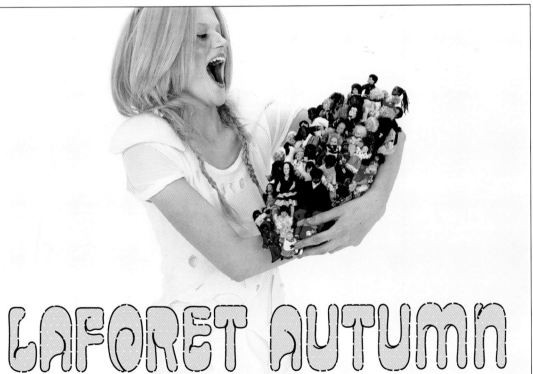

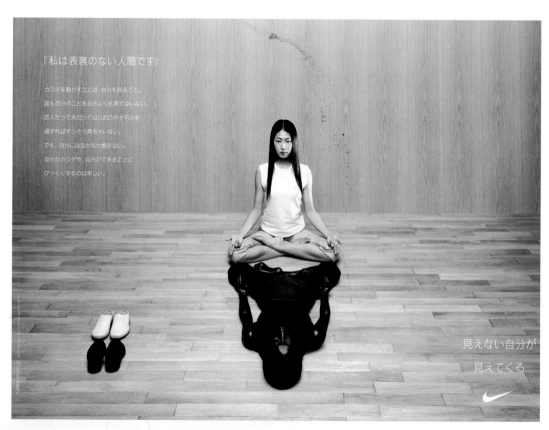

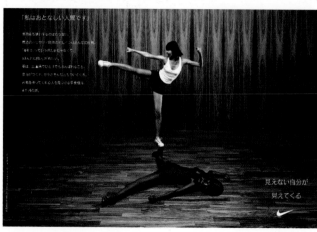

✿ see pages 7 and 13
right, below + left
**design agency: Uchu
Country Co. Ltd
client: Nike
art director/designer: Nagi
Noda**

Yin and *yang* appears to
be the concept for these
posters. In the "Gym" posters
(left), a young woman floors
her dark demons through
kickboxing or meditation.
In the "Swim" posters
(right and below), she is
dreamy and serene above
water, but tough and
Amazonian beneath.

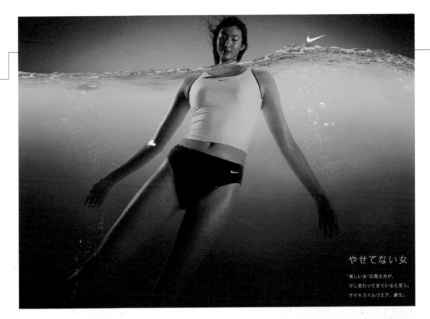

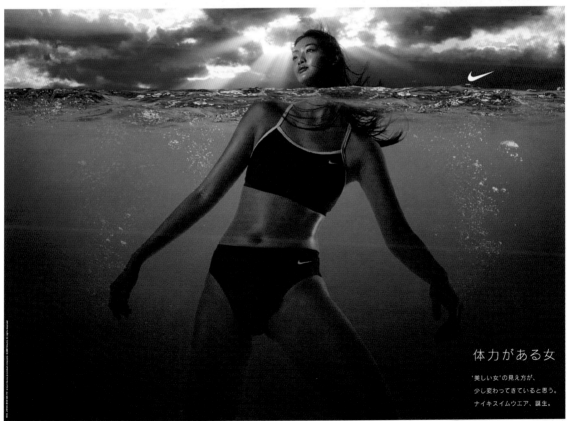

✿ see page 5
promotional poster
design agency/printer:
Graph Co. Ltd.
client: Sai-Sai Matsuri
summer festival
art director/designer: Issay
Kitagawa

This promotional poster for
a regional summer festival
shows loose brushstroke
images of fireworks, which
are often the main event at
such festivals in Japan.

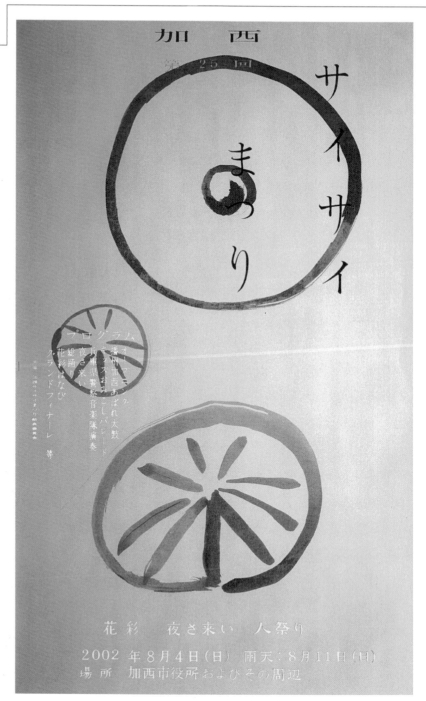

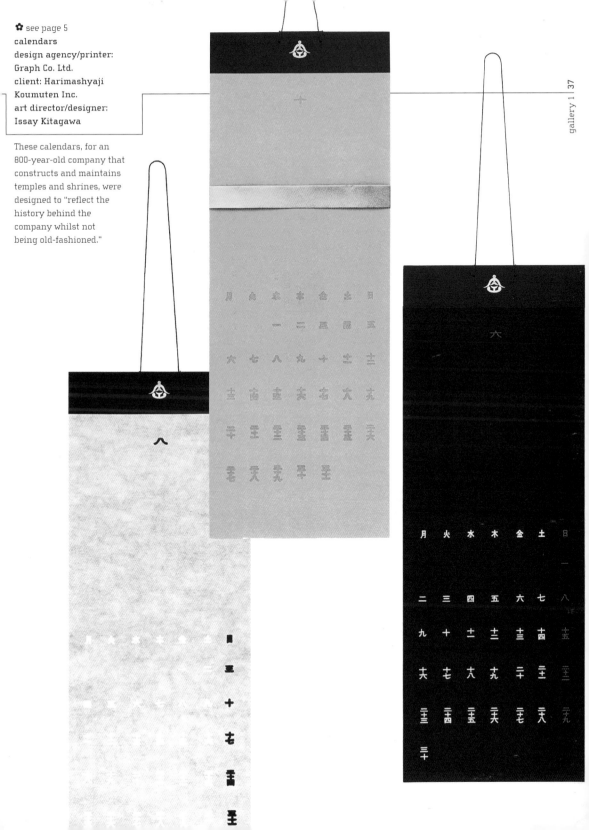

✿ see page 5
calendars
design agency/printer:
Graph Co. Ltd.
client: Harimashyaji
Koumuten Inc.
art director/designer:
Issay Kitagawa

These calendars, for an
800-year-old company that
constructs and maintains
temples and shrines, were
designed to "reflect the
history behind the
company whilst not
being old-fashioned."

✿ see page 5
promotional poster
design agency/printer:
Graph Co. Ltd.
client: PPCM
art director/designer: Issay
Kitagawa

✿ see page 5
promotional poster
design agency/printer:
Graph Co. Ltd.
client: PPCM
art director/designer: Issay
Kitagawa

This poster features the Chinese character for a word pronounced "hin," meaning "quality," boldly implying that clothing manufacturer PPCM produces quality clothes.

Graph designer Issay Kitagawa says that there are sinister aspects to this piece (admittedly not obvious to Western viewers), which was designed at a time when a large number of child murders were being revealed in Japan.

✿ see page 5
below
promotional poster
design agency/printer:
Graph Co. Ltd.
client: PPCM
art director/designer: Issay
Kitagawa

✿ see page 5
below right
promotional poster
design agency/printer:
Graph Co. Ltd.
client: PPCM
art director/designer: Issay
Kitagawa

"Out with the old and in with the new" is the theme of this poster, in which a traditional scene is depicted on a wheeled trash can.

Wheels appear again in this poster, which combines "classic" and "pop" themes. According to designer Kitagawa: "The left-hand chysanthemum is the national flower of the Emperor, indicating classic. The right-hand chrysanthemum on wheels indicates pop."

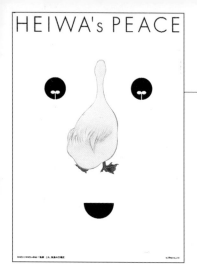

left + below
promotional posters
design agency: Ken Miki
& Associates
client: Heiwa Paper
Co. Ltd.
art director: Ken Miki

Heiwa, the name of this
paper company, means
"peace." Geese are used in
this promotional imagery
because geese mate for life
and are commonly used as
symbols of peace.

right
promotional poster
design agency: Ken Miki
& Associates
client: Expo 2005 Aichi
art director: Ken Miki

A web-like, continuous line
illustration connects man
to all other plant and
animal life in this poster
to promote the *Expo 2005
Aichi* exhibition. This simply
but effectively expresses
"nature's matrix," one of
the exhibition's themes.

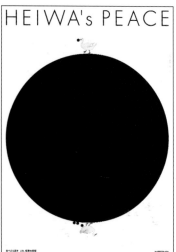

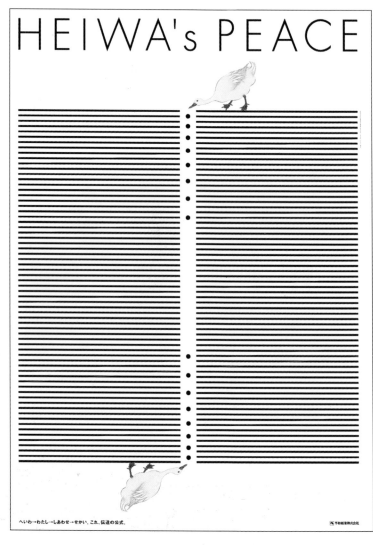

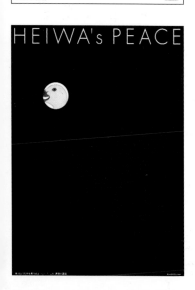

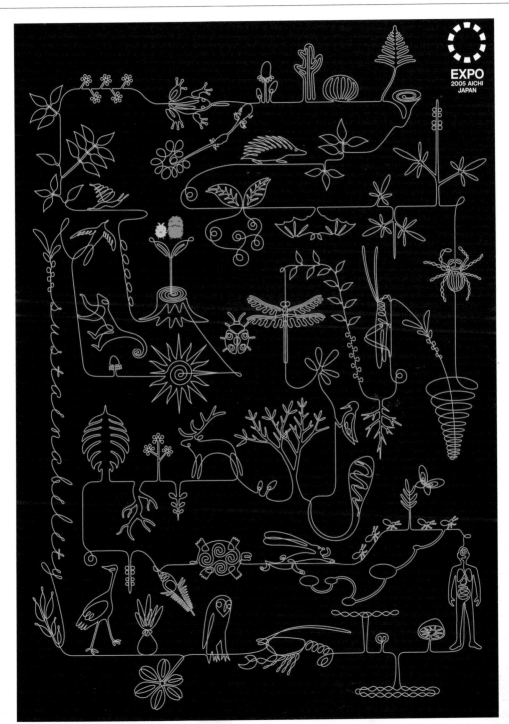

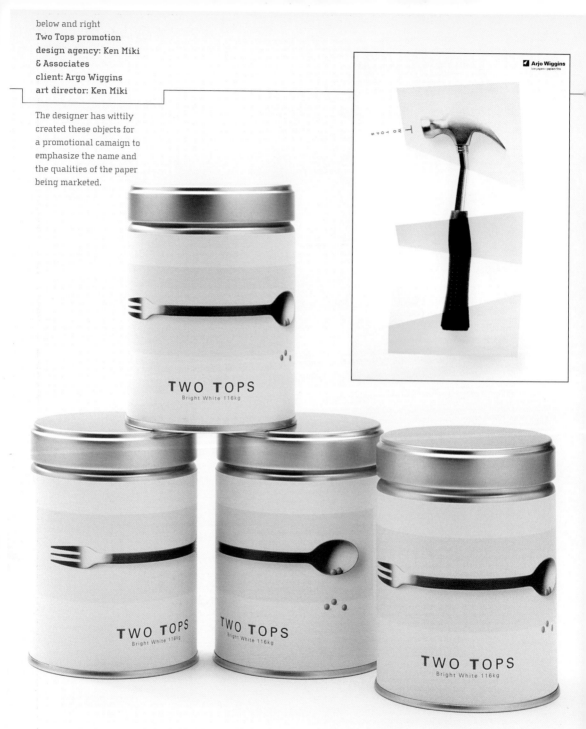

below and right
Two Tops promotion
design agency: Ken Miki
& Associates
client: Argo Wiggins
art director: Ken Miki

The designer has wittily
created these objects for
a promotional camaign to
emphasize the name and
the qualities of the paper
being marketed.

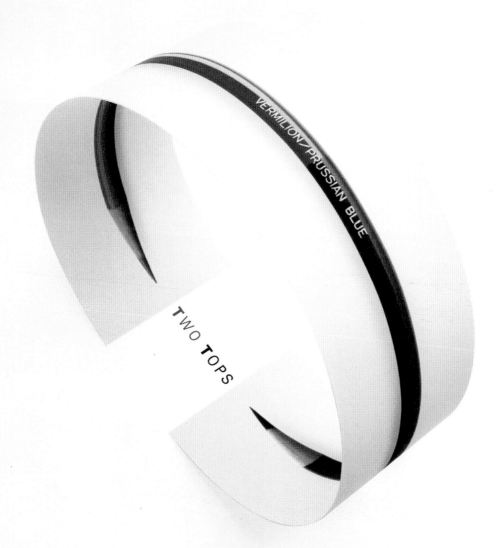

VERMILION/PRUSSIAN BLUE

TWO TOPS

below
exhibition posters
design agency: Ken Miki
& Associates
client: Argo Wiggins
art director: Ken Miki

These exhibition posters use color in a bright, lucid, and almost textural way.

right
promotional poster
design agency: Ken Miki
& Associates
client: Heiwa Paper Co. Ltd.
art director: Ken Miki

Heiwa Paper Co. Ltd. aimed to develop a paper as white as snow (the paper is called *Hokusetu*, or "Snow Mountain"). Therefore this poster features letters that reach up like snow-covered mountains. The designer's aim was to communicate "a sense of dignified 'whiteness' in perfectly still space."

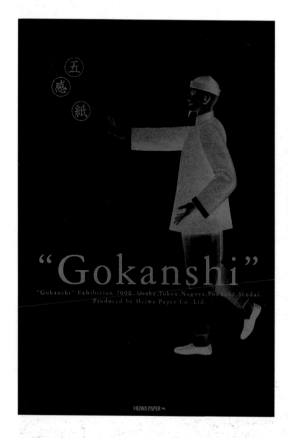

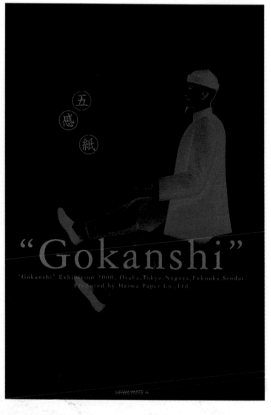

Hokusetu
Snow Mountain

HEIWA PAPER

below
promotional poster
design agency: Ken Miki
& Associates
client: Paper Voice/Heiwa
Paper Co. Ltd.
art director: Ken Miki

Simple graphic shapes adorn
this poster for Paper Voice, a
gallery in Osaka devoted to
fine paper.

right
exhibition poster
design agency: Ken Miki
& Associates
client: Suntory Collection
art director: Ken Miki

Many exhibitions in
Japan are concerned
with the theme of "beauty,"
particularly traditional
beauty. This poster for an
exhibition celebrating *Life
and Beauty from Japan and
the West* takes traditional
imagery and uses it in a
modern way.

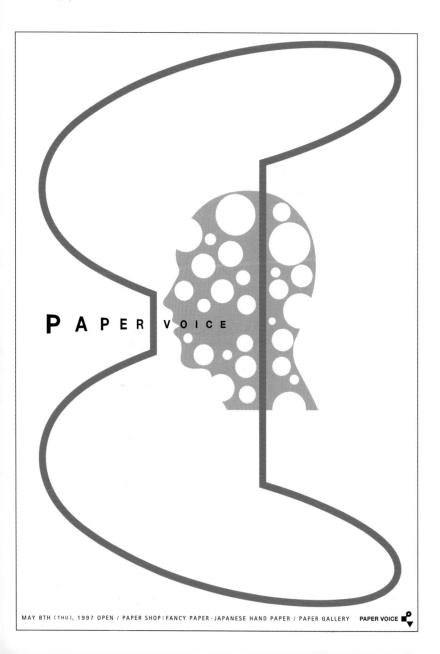

PAPER VOICE

MAY 8TH (THU), 1997 OPEN / PAPER SHOP : FANCY PAPER · JAPANESE HAND PAPER / PAPER GALLERY PAPER VOICE

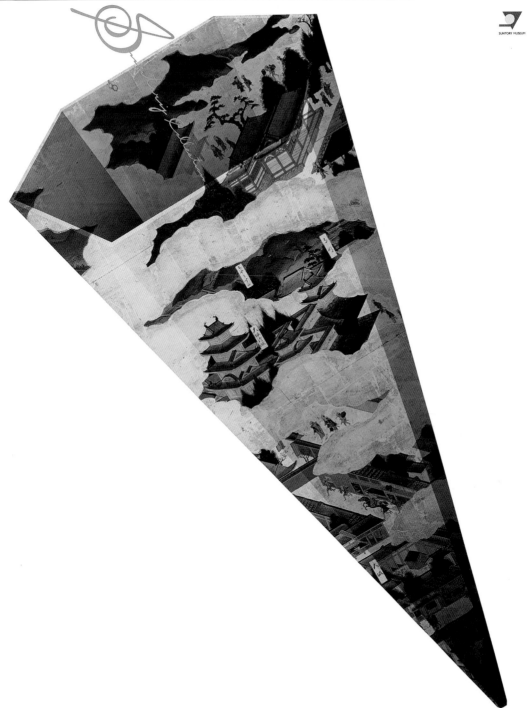

サントリー創業100周年記念展

サントリーコレクション－夢回廊

LIFE AND BEAUTY FROM JAPAN AND THE WEST
日本の生活美と西洋絵画・印象派から現代まで

会期／1999年11月20日(土)－2000年1月16日(日)　会場／サントリーミュージアム[天保山]ギャラリー

開館時間／10:30–19:30(最終入場は19:00まで)　入場料／大人1000円(900円)　高・大学生700円(630円)　小・中学生400円(360円)　()は前売入場券です。チケットぴあ、ローソンチケット、CNプレイガイドで発売しております。
休館日／毎週月曜日及び12月31日(11月22日、2000年1月3日・10日は開館いたします)　主催／サントリーミュージアム[天保山]、サントリー美術館　〒552–0022 大阪市港区海岸通1–5–10 Telephone 06-6577-0001 http://www.suntory.co.jp/culture/smt/

✿ see page 6
below **annual**
right **poster**
design agency: D-BROS
client: Tokyo Art Directors'
Club
art director/designer:
Yoshie Watanabe
creative director: Satoru
Miyata

Doodles appear on the cover
of the annual and poster for
the Tokyo Art Directors' Club.
Here, the doodles have a
1950s theme and (for no
obvious reason) celebrate a
famous Parisian landmark.

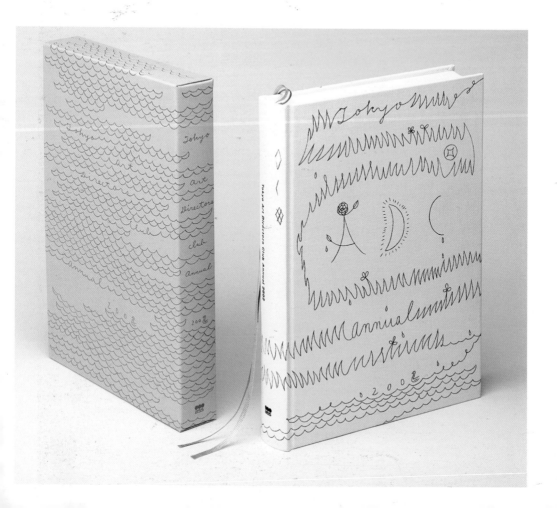

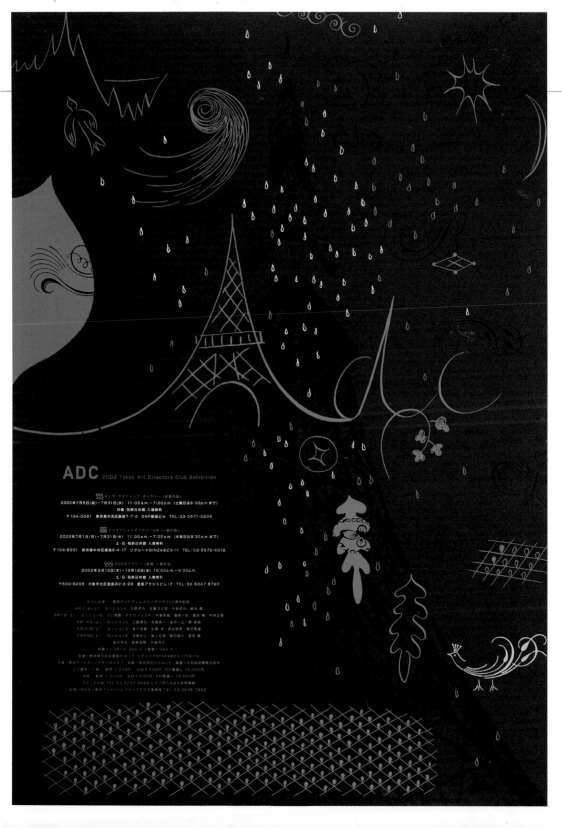

✿ see page 5
below + below right
book design
design agency: Nomade
client: Shogakukan
(publisher)
art director/designer:
Toshi Shiratani
photographer: Hiroh Kikai

This book's layout is simple
and clean, giving full visual
power to the photographs.

✿ see page 5
right
book design
design agency: Nomade
client: Sekaibunnkasya
(publisher)
art director/designer:
Toshi Shiratani
photographer:
Tadayuki Naito

This book design both
borrows and reveals the
subtle colors and ambience
of a traditional Japanese
rock garden.

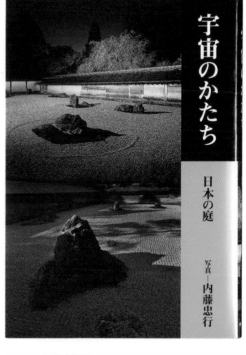

宇宙のかたち

日本の庭

写真—内藤忠行

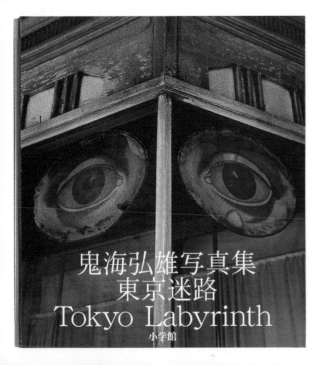

鬼海弘雄写真集
東京迷路
Tokyo Labyrinth
小学館

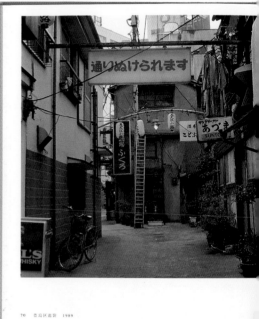

通りぬけられます

70　豊島区池袋　1989

✿ see page 5

below
book design
design agency: Nomade
client: Kodansha
(publisher)
art director/designer:
Toshi Shiratani

The Japanese love their
cherry blossom and
celebrate its arrival with
hanami (blossom viewing)
parties under the trees.
There are many books, like
this one, that celebrate such
seasonal beauty.

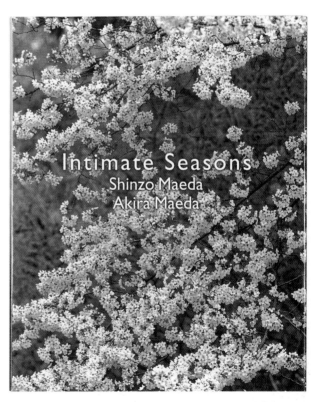

✿ see page 5

below
concert poster
design agency: Nomade
client: Asakusa Taiko
Jam Project
art director/designer:
Toshio Shiratani
illustrator: Eiichi Ito

The imagery on this poster
was inspired by a typical
decoration on the small
envelopes (pochi-bukuro)
traditionally used to give
cash gifts (see page 109).

✿ see page 5

tour poster
design agency: Nomade
client: Kodo
art director/designer:
Toshio Shiratani
photographer:
Katsumi Oomori

Kodo is a group of musicians
who explore the possibilities
of taiko, the traditional
Japanese drum. The name
"Kodo" conveys two
meanings: "heartbeat"
(the taiko's sound is said to
resemble a mother's
heartbeat as felt in the
womb); and "children of the
drum," a reflection of Kodo's
desire to play their drums
simply, with the heart of a
child. It is unsurprising,
then, that both the word
and the image of the drum
feature so strongly in the
group's posters.

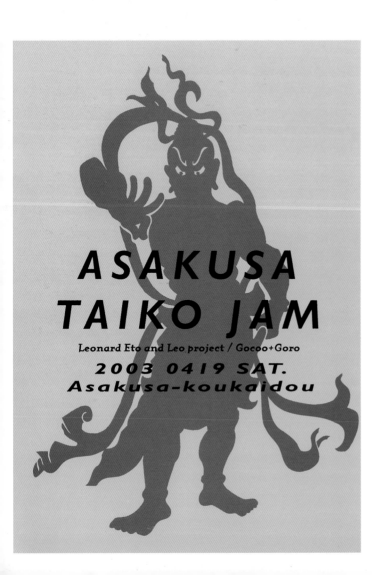

鼓童

KODŌ

ONE EARTH TOUR

✿ see page 5

below
CD sleeve design
design agency: Nomade
client: Kodo
art director/designer:
Toshio Shiratani
photographer: Rinko
Kawauchi

The Kodo musicians and
their families live as a
community on rural Sado
Island in western Japan.
The CD sleeve contains
images of everyday life
in their commune.

✿ see page 5

below
tour posters
design agency: Nomade
client: Kodo
art director/designer:
Toshio Shiratani
photographers: Rinko
Kawauchi (One Earth
poster)/Ljima Kaoru
(Gathering poster)

Gold and white are
considered to be positive and
uplifting colors in Japan.
Used together in these
posters, the colors create
a strong impact.

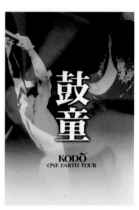

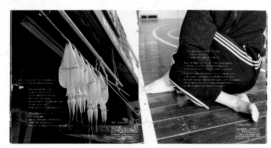

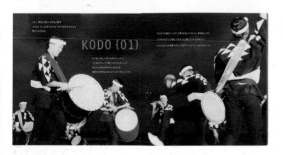

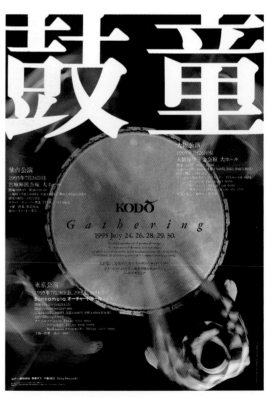

✿ see page 5

below right
tour poster
design agency: Nomade
client: Kodo
art director/designer:
Toshio Shiratani
photographer: Rinko
Kawauchi

There are 24 performing
members in Kodo. Here, the
majority are seen drumming
together on the beach.

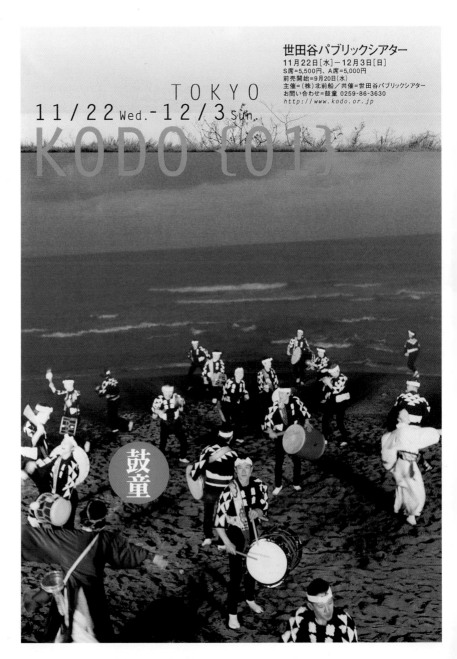

✿ see page 5
below
exhibition poster
design agency: Nomade
client: Tokyo Metropolitan
Museum of Modern
Photography
art director/designer:
Toshio Shiratani
photographer: Suizan
Kurokawa

The design of this poster, for
an exhibition called *The
Pictorial Landscape in
Japanese Photography*,
functions in the same way
as a traditional frame
around a central image.

✿ see page 5
below right
exhibition poster
design agency: Nomade
client: Tokyo Metropolitan
Museum of Modern
Photography
art director/designer:
Toshio Shiratani
photographer: Kinseo
Kuwabara

Commonly used colors in
Japanese design are black,
white, and gray, with an
accent (usually just a
slither or spot) of red.
Here, the colors are
used in a poster for a
photography exhibition.

✿ see page 5
bottom right
event poster
design agency: Nomade
client: Satoyama Project
art director/designer:
Toshio Shiratani
photographer: Mitsuhiko
Imamori

This poster is for an event
exploring the preservation
of rural communities and
the coexistence of people
with nature in the twenty-
first century.

✿ see page 5
right
exhibition poster
design agency: Nomade
client: Hara Museum
art director/designer:
Toshio Shiratani

Toko Shinoda (b. 1913) is
Japan's most celebrated
painter of abstract *sumi-e*
(ink paintings). This poster
intimately focuses on the
beauty of her brushstrokes.

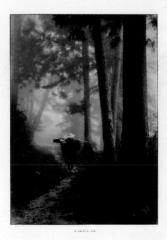

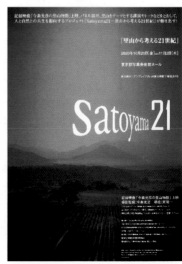

篠田桃紅

朱よ

二〇〇三年三月十八日（火）― 四月十三日（日）

原美術館

MARCH 18 - APRIL 13, 2003
HARA MUSEUM OF CONTEMPORARY ART
VARIATIONS OF VERMILLION

TOKO SHINODA

HARA
MUSEUM
東京都品川区北品川4-7-25 Tel：03-3445-0651 http://www.haramuseum.or.jp

editorial design
design agency: Pentagram
client: Nikkei Design
designer: Angus Hyland
design assistant: Akio
Morishima
photographer: Nick Turner

Each cover of *Nikkei Design*
(a technical magazine that
focuses on the relationship
between design and
business) depicts the issue's
theme. Issue 10 (far right),
for example, deals with
packaging for alcoholic
drinks; 11 (bottom right)
with survival strategies
during the Japanese
recession; and 12 (below)
with goods for *oyaji* (middle-
aged/middle management
consumers). Pentagram's
Angus Hyland was originally
approached to design just
three covers, but they
proved so successful that
he went on to design twelve.

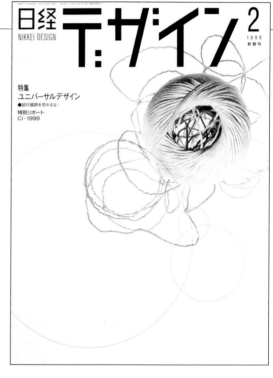

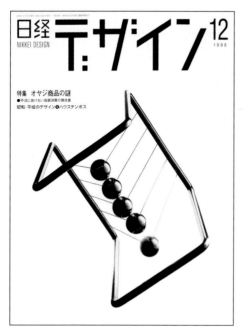

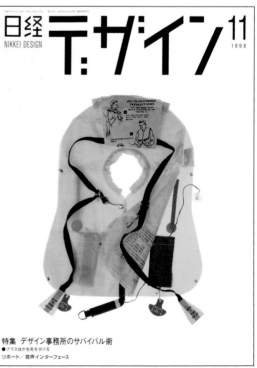

98年9月22日発行（毎月1回22日発行） 第136号　1987年8月18日第三種郵便物認可

日経デザイン

NIKKEI DESIGN

10

1998

特集　酒のパッケージ

● 普段着のデザインへ

リポート／障害者とコンピューター

below
promotional poster
art director/designer: Akio
Okumura
client: Gallery Interform

right
promotional poster
art director/designer: Akio
Okumura
client: Gallery Interform

By playing around with
the shapes in the initials
of the gallery's name,
Akio Okumura has found a
pleasing idea for this poster.

This poster uses bold
graphic typographic
symbols to convey
information.

インターメディウム研究所は、

秦那祐之（メディアアーティスト／インターフェイスデザイン研究領域）

芸術（アート）と科学（サイエンス）の

差点

インターメディウム研究所・IMI大学院スクールは、
芸術と科学の交差点。

2003年度（第8期）研究生募集

インターメディウム研究所・IMI大学院スクールは、1996年の開講
以来、情報・文化およびメディア産業界で創造力を発揮する人材を
多数輩出し、また新しい創造のための豊かなコンテンツを育んでき
ました。
芸術系・文系・理系などさまざまなバックグラウンドを持つ研究生
が全国から集い、映像、デザイン、サウンド、ネットワーク、建築、
編集、文化、哲学、アートマネジメントなど多様な領域を横断的
に学び、さらにはCS番組やWebコンテンツ制作など、社会と関わ
る実践的プロジェクトに参加し研鑽がつめる、国際的なプロフェッ
ショナル・スクールとして全面的に大きな注目を集めています。

IMI大学院スクール　説明会日程
9月15日（日）10月6日（日）10月13日（日）10月26日（土）
11月4日（月・祝）11月23日（土）12月7日（土）12月14日（土）
各日13:00〜14:30開催
内容：映像によるカリキュラム紹介、講師によるミニレクチャー施設見学、
個別進路相談など
会場：インターメディウム研究所（千里万博公園内）

M1コース、M0コース　前期特別AO入試開催
第1回研究生募集にともない、前期特別AO入試を行います。
前期特別AO入試日程：2002年9月29日（日）
出願期間：9月9日（月）〜9月19日（水）

特別AO入試合格者のための
・アドミニストレーション講座、特別講座など本年度開催のレクチャーを一部受講できる
・夜間メディア図書館を利用でき、IMIのレクチャービデオなどの映像資料を閲覧できる
・合格者のための特別レクチャーを開催する

IMI大学院スクールの各コース

文系学群
法学・社会学・文学・美学　→

芸術系大学
美術・映像・デザイン・音楽　→

理工系大学
建築・生物学・数学・情報工学　→

短期大学
デザイン・文学・生活科　→

アート系専門学校
メディア学・写真・ファッション　→

社会人
デザイナー、編集・印刷会社、
システムエンジニア　→

ダブルスクール
大学生、大学院生　→

M2
M1
M0
夜間

→ アーティスト

→ 編集者、ディレクター

→ クリエイター・ユニット、
ベンチャー企業

→ デザイン事務所、映像プロダクション

→ Web制作などのSOHOクリエイター

→ 海外、他の大学院

→ デジタル・アート系学校講師

→ IMIグループのスタッフ

M1コース
ハイレベルのプロの表現者をめざし、世界の第一
線で活躍するアーティストやディレクター、研究
者とのワークショップを通して実践的な技術と技
術を学ぶ、社会と直結するコース。
（募集人数100名）

2002年度IMI・M1コース 講師陣一覧
ヴィジョン・セオリー／アドミニストレーション／エレメンタリー・ラボ・ワークス／スペシャルレクチャー／
セオリー・ディレクション／メディア編集＆ディレクション／映像プロデュース／地域プロデュース／
アートラボ・ジェント（パフォーミング・アート）／グラフィック／ネットワークデザイン／
デジタル・ピクチャー／モーション・ピクチャー／サウンドデザイン／インターフェイスラボ／プログラミング／
アートドキュメンタリー／現代美術／写真／建築

M0コース
多様なメディアを横断しながら表現が求められるデジ
タル時代のクリエイターとなる人のため、幅広い
（視覚と調査を基礎から習得するネット上展開からワー
クショップコース。講師は半日の固定に限定。）
（募集人数40名）

2002年度M0・夜間コース講座一覧 Graphic Design／DTP、Movie／CG、Photography、Web／Network…一般教養

M2コース
M1を修了した研究生が、それぞれの専門分野での
更なる研鑽を積むために、ティーチングアシスタ
ント＆特別研究生として講師の助手を勤め
ながら2年目を研究、制作活動も行うコース。

夜間コース
多様なメディアを横断し各専門分野での研究を（19:00〜21:45）、技術と思考の両面
を研鑽するIMIカリキュラムのエッセンスを集中的
に学ぶ、ダブルスクール可能でだれでも
受講可能なコース。（募集人数40名）

インターメディウム研究所・IMI大学院スクール
問い合わせ専用フリーダイアル■■0120-366 603
phone 06-6816-4562　fax 06-6816-4588
e-mail: office@iminet.ac.jp／http://www.iminet.ac.jp/

below + right
promotional posters
art director/designer: Akio Okumura
client: Gallery Interform

In the poster opposite, Akio Okumura rejects the cursive and uses symbols made from solid square or rectangular shapes. In the images below, however, people are not represented by such rigid shapes. Instead, faces are pixelated and converted into circles of varying sizes.

Inter Medium Institute

プ

メ

学

共

い

デ

体

芸

IMI大学院スクール＋彩都メディアラボは、高品質なプロジェクトを社会に発信しています。
メディア産業、アートの現場に飛び込むプロ直伝の思考と技術を学ぶIMI大学院スクール

「IMI大学院スクール」はメディア系大学院の産学共同研修センターをめざしています。

インターメディウム研究所・IMI大学院スクール
問い合わせ専用フリーダイアル ☎ 0120-366 603
〒565-0826
大阪府吹田市千里万博公園1番1号 万博記念ビル 1F
phone 06-6816-4563　fax 06-6816-4565
e-mail：info@iminet.ac.jp　http://www.iminet.ac.jp/

http://www.iminet.ac.jp/
e-mail：info@iminet.ac.jp

大学でもない。会社でもない。社会を疑似体験しながら学ぶ、新しい形の学校。

デジタル化が進む社会は、芸術的な思考力を求めています・・・
2004年春、IMI大学院スクールという選択。

インターメディウム研究所・IMI大学院スクール
2004年度（第9期）研究生募集

IMI大学院スクールは、デジタルテクノロジーと結びつい
た影響力メディアデザインとアート（グラフィック・WEB・
映像・コンピュータグラフィック・サウンド・データベー
ス・インターフェイス・現代美術・アートマネージメント
など）の制作を軸に、講師陣がリードする第一線のアート
の現場や彩都開発にかかわるさまざまなフィールドワーク
から、先端的なプロジェクトへのインターン参加をカリ
キュラムに織り込んだ、時代を切り開くプロフェッショナ
ル養成の大学院スクールです。

IMI大学院スクール　スクールガイダンス日程［大阪］
1月11日（日）　1月18日（日）　2月 1日（日）
2月 7日（土）　2月14日（土）　2月22日（日）
各日13:00～15:00開催（2月7日（土）のみ16:00～18:00）
会場：インターメディウム研究所（千里万博公園内）

IMI大学院スクール　スクールガイダンス日程［京都］
1月24日（土）19:00～20:30
会場：キャンパスプラザ京都
内容：映像によるカリキュラム紹介、講師によるミニレクチャー、
個別面談相談など

M1コース、M2コース　AO入試開催
第6期研究生募集にともない、以下の日程で入試を行います。
第3回 AO 入試日程：2004年　1月25日（日）
第4回 AO 入試日程：2004年　2月14日（土）
第5回 AO 入試日程：2004年　3月14日（日）
第6回 AO 入試日程：2004年　4月18日（日）

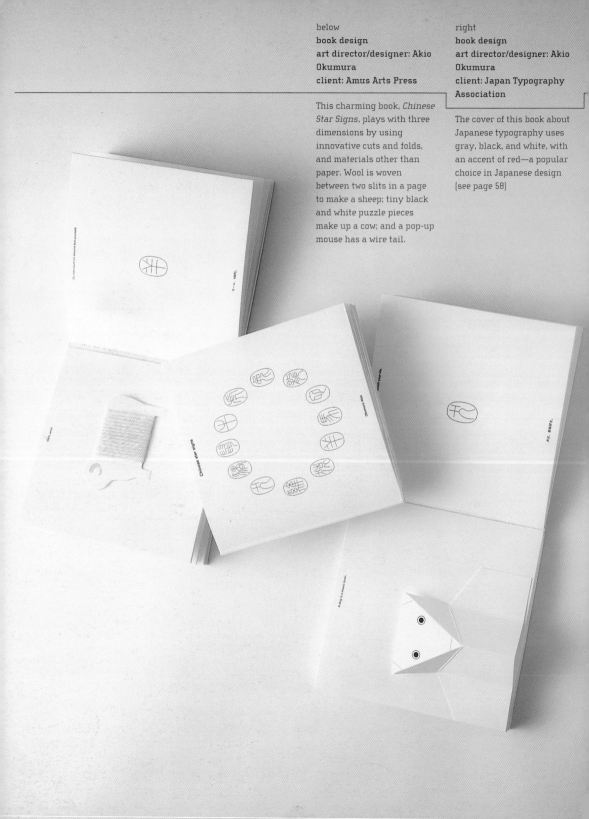

below
book design
art director/designer: Akio
Okumura
client: Amus Arts Press

This charming book, *Chinese
Star Signs*, plays with three
dimensions by using
innovative cuts and folds,
and materials other than
paper. Wool is woven
between two slits in a page
to make a sheep; tiny black
and white puzzle pieces
make up a cow; and a pop-up
mouse has a wire tail.

right
book design
art director/designer: Akio
Okumura
client: Japan Typography
Association

The cover of this book about
Japanese typography uses
gray, black, and white, with
an accent of red—a popular
choice in Japanese design
(see page 58)

✿ see page 15

left
poster
designer: Noriyuki Tanaka
client: Renaissance
Generation 2003/Kanazawa
Institute of Technology

✿ see page 15

below
poster
designer: Noriyuki Tanaka
client: Pandora no kane
(theater performance)

Noriyuki Tanaka's poster
for an interactive media
exhibition seems to be
inspired by test cards—the
images that were broadcast
in the early days of
television, usually late at
night when no programmes
were being shown.

This poster for a theater
performance shows the faces
of the entire cast shooting
out of the protagonist's
mouth in a cartoon-like way
that is also reminiscent of
propoganda posters.

left
exhibition poster
art director/designer:
Noriyuki Tanaka
client: Tokyo Type
Directors' Club

Serifs seem to be melting, and drip down a page punctuated by patterned, cloud-like formations. Look closely, and fairy tale-like animals, such as unicorns, lions, and birds, are visible.

right + below
posters
design agency: Hakuhodo
client: World Wildlife Fund
for Nature (WWF)
art director: Kazufumi
Nagai

This award-winning series
of poster advertisements
appeals to the need to
preserve the natural
environment.

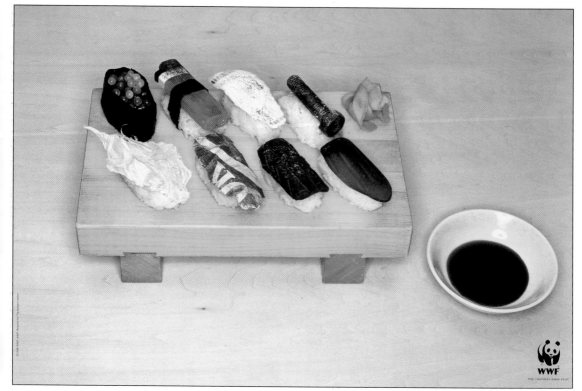

below
posters
design agency: Hakuhodo
client: kkk
art director: Kazufumi
Nagai

This series of posters shows
a pleasing visual wit.

below + right
poster series
art director/designer:
Hideki Nakajima
client: Parco Gallery
photography and
copywriting: Ryuichi
Sakamoto

The experimental poster
series S/N 1 was designed
for an exhibition of graphic
designers' works called *Code
Exhibition: New Village*.

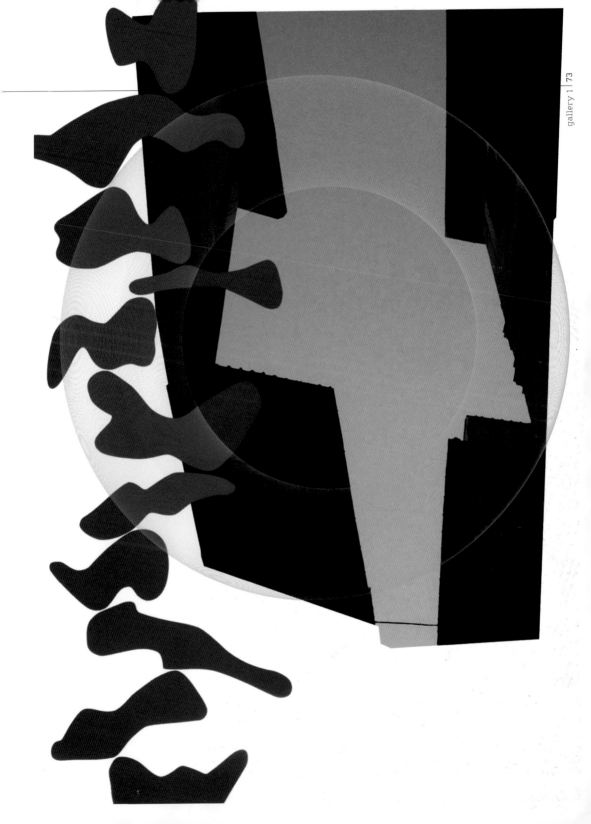

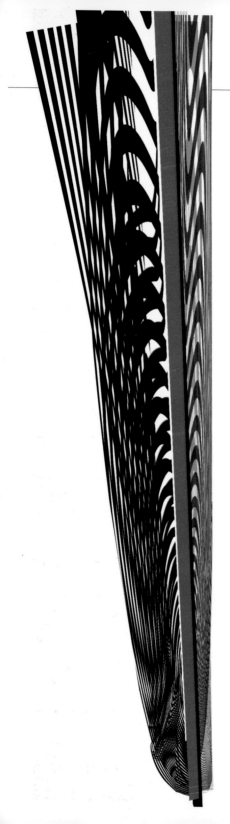

left + right
poster series
art director/designer:
Hideki Nakajima
client: Parco Gallery
photography and
copywriting: Ryuichi
Sakamoto

A second series (S/N 2)
of imagery from *Code
Exhibition: New Village*. The
series of images on the right
show each stage of a digital
image as it is zoomed into,
up until a single pixel.

below + right
**original artwork
art director/designer:
Hideki Nakajima
client: IDEA magazine**

IDEA magazine invites a different designer to create imagery for a large block of pages in each issue. Freed from the constraints of commercial clients, designers can produce experimental, innovative work, such as the images by Hideki Nakajima, titled *Recycling*, shown here.

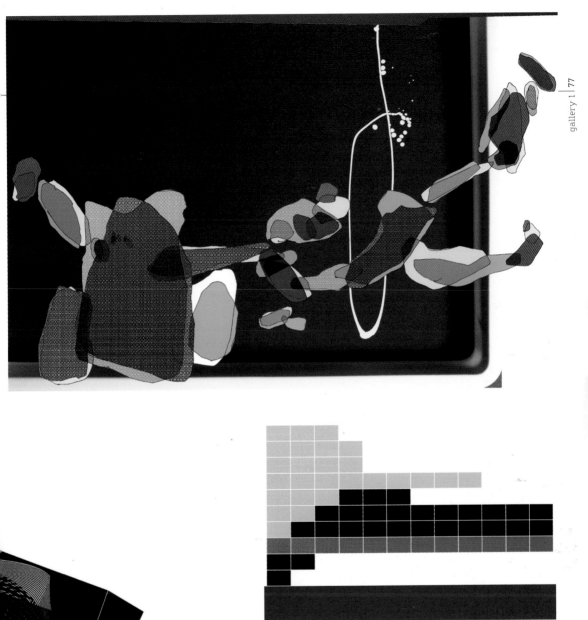

below + right
original artwork
art director/designer:
Hideki Nakajima
client: IDEA magazine

Further examples of work
from *Recycling* (see pages
76–77).

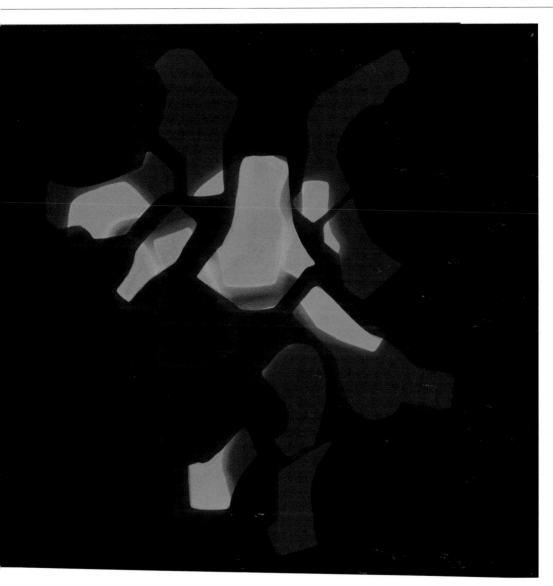

EXPO 2005
JAPAN

2005年日本国際博覧会　新しい地球創造：自然の叡智

THE 2005 WORLD EXPOSITION, JAPAN　BEYOND DEVELOPMENT: REDISCOVERING NATURE'S WISDOM

✿ see page 99

left + below
exhibition posters
design agency: Hara
Design Institute/Nippon
Design Center
client: Expo 2005 Aichi
art director: Kenya Hara

These posters were designed
for an exhibition examining
ecology and the future
relationship between
humankind and nature.

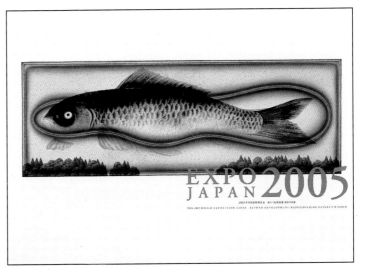

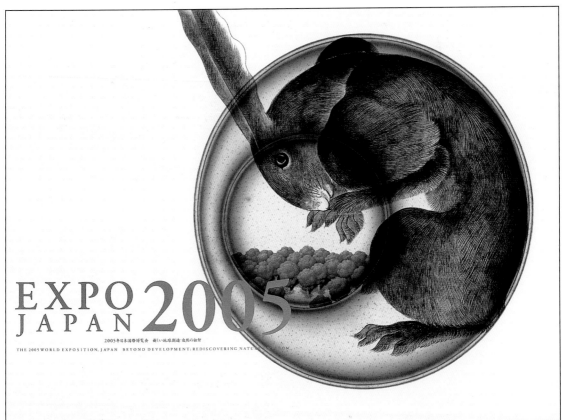

✿ see page 99
below **calendars**
right **packing tape**
design agency: Hara
Design Institute/Nippon
Design Center
client: Expo 2005 Aichi
art director: Kenya Hara

Kenya Hara also designed
calendars and packing tape
to promote *Expo 2005* (see
pages 80–81). Japanese
packages often arrive
wrapped in decorative tape
such as that shown right.

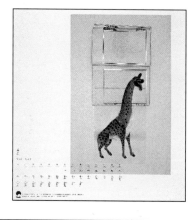

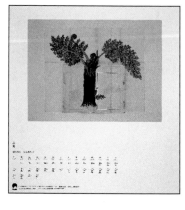

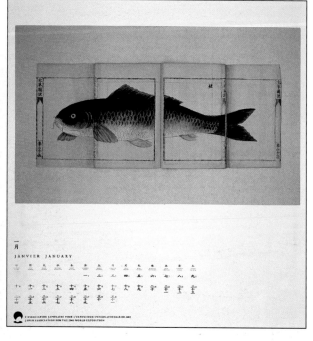

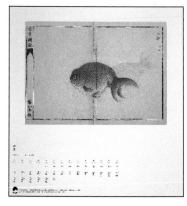

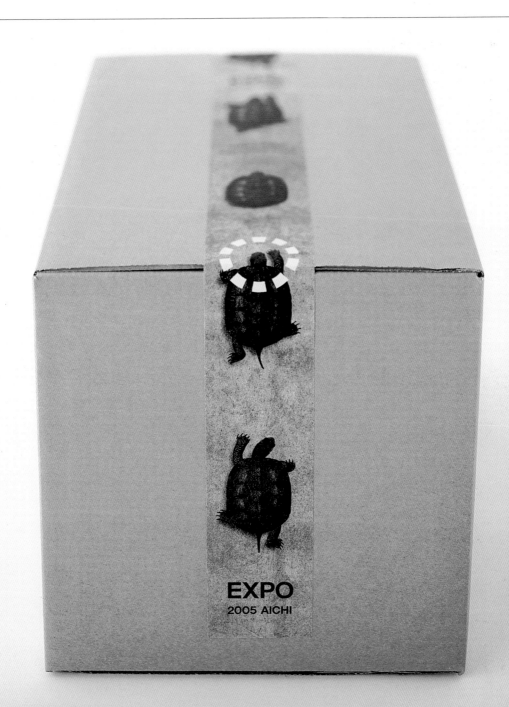

✿ see page 99

below + right
book design
design agency: Hara
Design Institute/Nippon
Design Center
client: Nagano Olympics
art director: Kenya Hara

Vibrantly colored
illustrations fill the pages of
this book commemorating
the opening ceremony of the
Nagano Olympics in 1998.

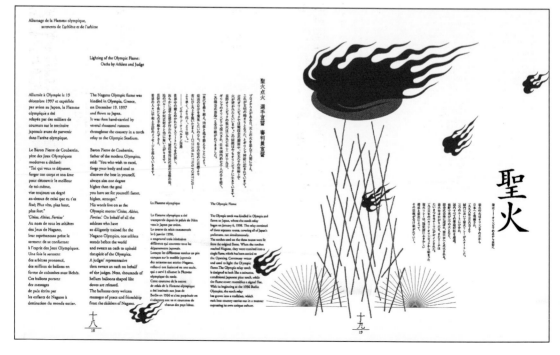

選手入場

L'entrée des athlètes

The Parade of Athletes

Jamais les Jeux Olympiques d'hiver n'ont compté autant de pays et de régions, d'athlètes et d'athlètes. Précédés par les lutteurs de Sumo du Grand tournoi, les athlètes font enfin leur entrée. Leurs costumes officiels olympiques constituent une attraction en soi pour les 50 000 spectateurs qui applaudissent avec ferveur les athlètes qui se sont longuement préparés pour l'occasion.

Led by sumo wrestlers and the children, the athletes enter the arena. This parade represents the largest number of countries and regions, athletes and officials ever to participate in a Winter Games. The entrance of the athletes, proudly parading in their official Olympic uniforms, is one of the highlights of the Opening Ceremony. The athletes, who have made exhaustive preparations for this occasion, are greeted with warm applause by the audience of 50,000.

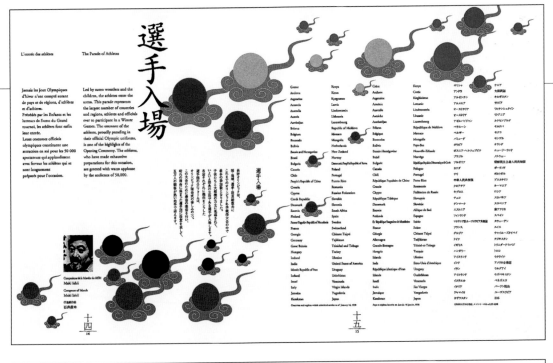

Compositeur de la Marche du défilé
Maki Ishii
Composer of March
Maki Ishii
行進曲作曲
石井眞木

Greece	Kenya	Grèce	Kenya	ギリシャ	ケニア
Andorra	Korea	Andorre	Corée	アンドラ	大韓民国
Argentina	Kyrgyzstan	Argentine	Kirghizistan	アルゼンチン	キルギスタン
Armenia	Latvia	Arménie	Lettonie	アルメニア	ラトビア
Australia	Liechtenstein	Australie	Liechtenstein	オーストラリア	リヒテンシュタイン
Austria	Lithuania	Autriche	Lituanie	オーストリア	リトアニア
Azerbaijan	Luxembourg	Azerbaïdjan	Luxembourg	アゼルバイジャン	ルクセンブルグ
Belarus	Republic of Moldova	Bélarus	République de Moldova	ベラルーシ	モルドバ
Belgium	Monaco	Belgique	Monaco	ベルギー	モナコ
Bosnia and Herzegovina	Mongolia	Bosnie-Herzégovine	Mongolie	ボスニア・ヘルツェゴビナ	モンゴル
Brazil	Norway	Brésil	Norvège	ブラジル	ノルウェー
Bulgaria	Democratic People's Republic of Korea	Bulgarie	République Populaire Démocratique de Corée	ブルガリア	朝鮮民主主義人民共和国
Canada	Poland	Canada	Pologne	カナダ	ポーランド
Chile	Portugal	Chili	Portugal	チリ	ポルトガル
People's Republic of China	Puerto Rico	République Populaire de Chine	Puerto Rico	中華人民共和国	プエルトリコ
Croatia	Romania	Croatie	Roumanie	クロアチア	ルーマニア
Cyprus	Russian Federation	Chypre	Fédération de Russie	キプロス	ロシア
Czech Republic	Slovakia	République Tchèque	Slovaquie	チェコ	スロバキア
Denmark	Slovenia	Danemark	Slovénie	デンマーク	スロベニア
Estonia	South Africa	Estonie	Afrique du Sud	エストニア	南アフリカ
Finland	Spain	Finlande	Espagne	フィンランド	スペイン
Former Yugoslav Republic of Macedonia	Sweden	Ex-République Yougoslave de Macédoine	Suède	マケドニア旧ユーゴスラビア共和国	スウェーデン
France	Switzerland	France	Suisse	フランス	スイス
Georgia	Chinese Taipei	Géorgie	Taïpei-Chinois	グルジア	チャイニーズ・タイペイ
Germany	Tajikistan	Allemagne	Tadjikistan	ドイツ	タジキスタン
Great Britain	Trinidad and Tobago	Grande-Bretagne	Trinité-et-Tobago	イギリス	トリニダード・トバゴ
Hungary	Turkey	Hongrie	Turquie	ハンガリー	トルコ
Iceland	Ukraine	Islande	Ukraine	アイスランド	ウクライナ
India	United States of America	Inde	Etats-Unis d'Amérique	インド	アメリカ合衆国
Islamic Republic of Iran	Uruguay	République Islamique d'Iran	Uruguay	イラン	ウルグアイ
Israel	Uzbekistan	Israël	Ouzbékistan	イスラエル	ウズベキスタン
Israel	Venezuela	Israël	Venezuela	イスラエル	ベネズエラ
Italy	Virgin Islands	Italie	Iles Vierges	イタリア	バージン諸島
Jamaica	Yugoslavia	Jamaïque	Yougoslavie	ジャマイカ	ユーゴスラビア
Kazakstan	Japan	Kazakstan	Japon	カザフスタン	日本

御柱

L'érection des Onbashira va transformer le stade en espace sacré.

Raising of the Onbashira to Consecrate "Sacred Ground"

Le chœur entonne un chant sacré alors que des milliers d'habitants de la région de Nagano s'apprêtent à ériger huit arbres géants de plus de dix mètres, les onbashira. Il s'agit d'une coutume ancestrale de Suwa, une région proche de Nagano. La croyance veut que dresser des arbres coupés dans la forêt contribue à purifier l'espace. Ces arbres, censés abriter des divinités, figurent les quatre portes de l'Est, de l'Ouest, du Sud et du Nord. A Nagano, la nature est à la fois bienveillante et hostile. Après un hiver habituellement rigoureux et enneigé, les habitants attendent avec impatience la venue du printemps. Dans la rudesse de cet environnement, sont nés ces sentiments de peur et de respect de la Nature qui ont inspiré ces rites et croyances. C'est un usisant leur esprit et leurs forces que ces hommes parviennent à dresser des sapins pesant chacun deux tonnes. Ainsi, le site de l'ouverture des Jeux s'est transformé par l'érection du onbashira en un espace sacré apte à accueillir les athlètes.

To the sound of celebratory singing, more than 1,000 local people make their entrance. Eight ceremonial wooden pillars over 10 metres tall, known as onbashira, are raised in the arena to form four gates: north, south, east, and west. The Onbashira Festival, originating in the Suwa region of Nagano Prefecture, is a tradition handed down from ancient times. According to ancient Japanese beliefs, gods reside in the wood of these pillars. People in the Suwa region have long believed that the way to purify a place is by erecting pillars cut from mountain forests. Year after year, Nagano residents endure long, snow-blanketed winters, while eagerly anticipating the first breath of spring. These conditions have engendered an awe of nature and an abiding respect for the environment. This wish to coexist in harmony with nature manifests itself in folk festivals passed down over the ages. The raising of the onbashira transforms the Olympic Stadium into a sacred arena, ready to welcome the athletes.

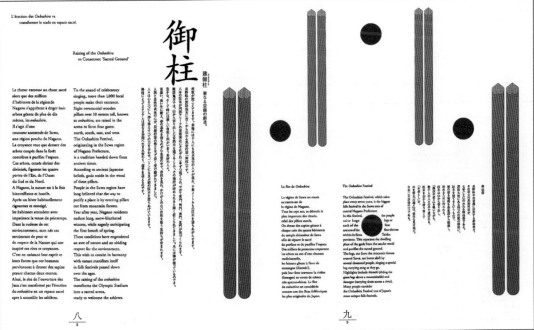

La fête de Onbashira

La région de Suwa est située au centre-est de la région de Nagano. Tous les sept ans, se déroule le plus important des rituels, celui des piliers sacrés. On dresse des sapins géants à chaque coin des quatre bâtiments du temple shintoïste de Suwa afin de séparer le sacré du profane et de purifier l'espace. Des milliers de personnes emportent les arbres au son d'une chanson traditionnelle, les faisant glisser à flanc de montagne (kiotoshi), puis leur font traverser la rivière (kawagoe) au cours de scènes très spectaculaires. La fête de onbashira est considérée comme une des fêtes folkloriques les plus originales du Japon.

The Onbashira Festival

The Onbashira Festival, which takes place every seven years, is the biggest folk festival in the Suwa area of central Nagano Prefecture. In this festival, the people raise huge logs at each of the four corners of the outside of the temple buildings within the Suwa Taisha province. This separates the dwelling place of the gods from the secular world and purifies the sacred ground. The logs, cut from the mountain forests around Suwa, are borne aloft by several thousand people, singing a special log-carrying song as they go. Highlights include kiotoshi (sliding the giant logs down a mountainside) and kawagoe (carrying them across a river). Many people consider the Onbashira Festival one of Japan's most unique folk festivals.

✿ see page 99

below + right
promotional posters
design agency: Hara
Design Institute/Nippon
Design Center
client: Musubi
art director: Kenya Hara

Musubi is Japanese for the art of "tying and knotting." This poster design focuses on decorative shapes made by a tied piece of cord.

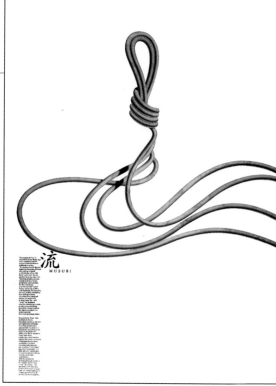

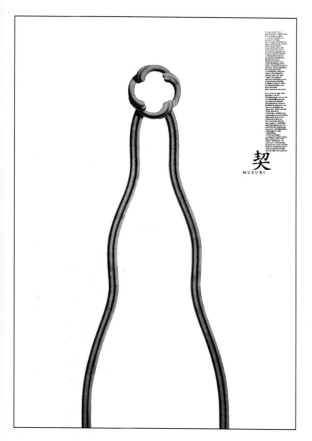

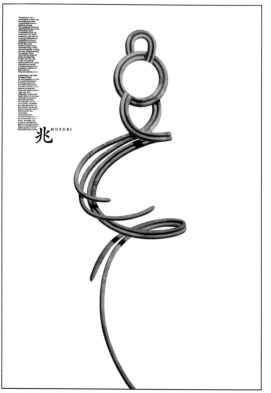

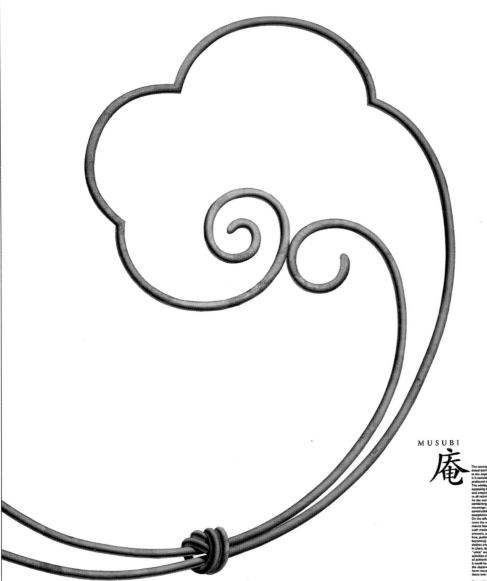

MUSUBI

庵

The concept of "ie" is
dated back to the Stone Age.
In the Japanese culture,
it is considered to have a
profound meaning.
The analogy behind the two
opposing constructs of tying
and untying is found
in all activities of our life.
As the word "tie" means
containing, it also has such
meanings of achievement,
construction of a house,
completion and romance.
On the other hand,
since the word of "untie"
means loosening, it offers
such meanings like revealing
answers, setting something
free, putting in order,
becoming free, taking off
clothes and beginning.
In short, both "tie" and
"untie" are profound
activities containing a sense
of achieving something.
It could be interpreted that
the Japanese culture has
been woven by
these two opposing values.

O conceito de "laço" data
da Idade da Pedra.
Na cultura japonesa, ele tem
um significado profundo.
A analogia por trás dos
atos opostos de amarrar e
desamarrar encontra-se em
todas as atividades da
nossa vida. Como a palavra
"laço" quer dizer
combinação, também tem
significados como realização,
construção de uma casa,
conclusão e romance.
Por outro lado, uma vez
que a palavra "desenlaçar"
quer dizer desprender, ela
pode oferecer significados
como a revelação de respostas,
a libertação de algo,
a arrumação,
a libertação própria,
a remoção de roupas e o início.
Em resumo, tanto "laço"
como "desenlaçar" são
atividades profundas que
contém um senso de realização.
Pode ser interpretado que a
cultura japonesa é tecida
por estes dois valores opostos.

✿ see pages 13 and 99

left + right
concept book for 2003 Milan Salone
design agency: Hara Design Institute/Nippon Design Center
client: Muji
art director: Kenya Hara

Muji products (see pages 99–100) are photographed within huge, empty, horizon-dominated landscapes or against skies so that they look as if they belong to (or are in harmony with) nature.

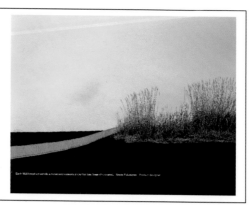

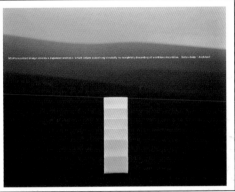

MUJI's business strategy reveals a Japanese aesthetic which values establishing continuity by completely dissolving all worthless encumbrance. Tadao Ando / Architect

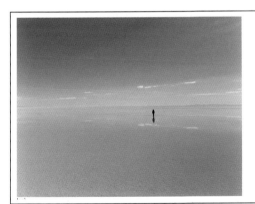

International MUJI

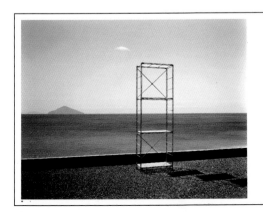
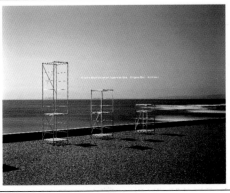

Horizon.Bolivia salt lake (Uyuni flat) · Archives

✿ see pages 13 and 99

left, below + right
promotional posters
design agency: Hara
Design Institute/Nippon
Design Center
client: Muji
art director: Kenya Hara

Here, the wide expanses of
the Mongolian landscape,
sky and land linked by a
logo, are used to express
the simplicity embodied
in the Muji brand.

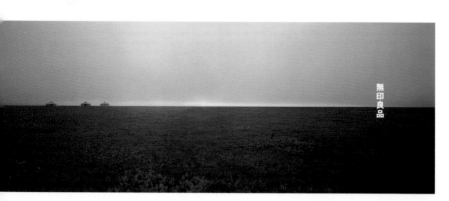

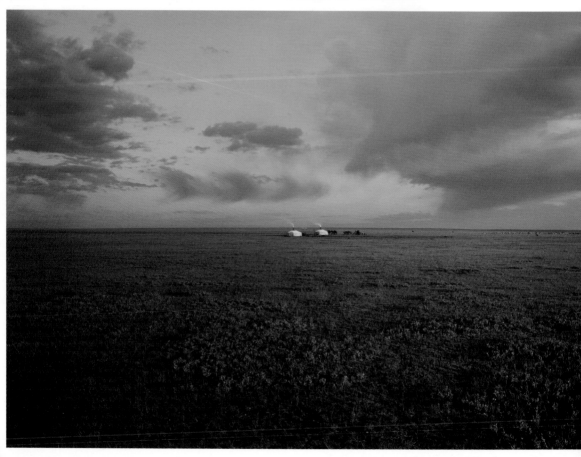

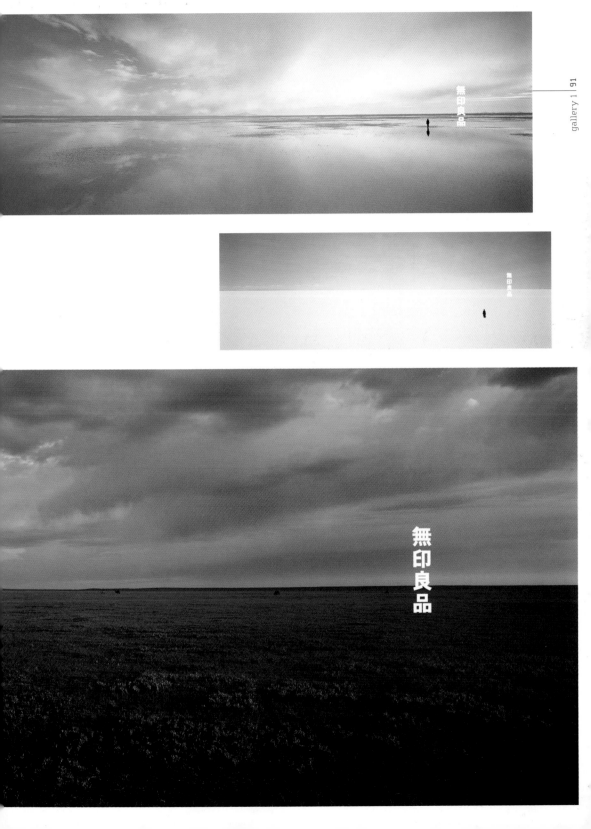

✿ see pages 13 and 99
right + far right
**magazine advertisements
2003
design agency: Hara
Design Institute/Nippon
Design Center
client: Muji
art director: Kenya Hara**

In this ad campaign, Muji
products are seen taken out
of their urban environments,
photographed at home
with nature.

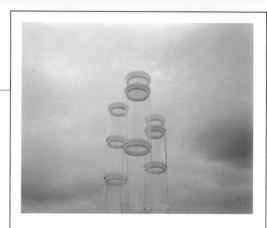

無印良品

無印良品

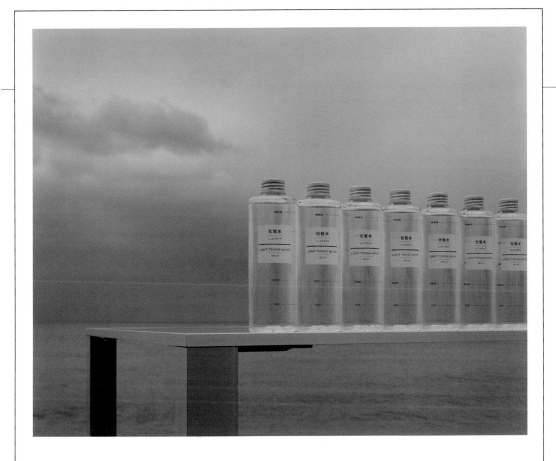

無印良品

✿ see pages 13 and 99–100
below + right
**magazine advertisements
2002
design agency: Hara
Design Institute/Nippon
Design Center
client: Muji
art director: Kenya Hara**

These ads emphasize the
utilitarianism of Muji
products. The poster on the
right shows their fan-like
CD player (see page 100).

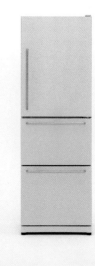

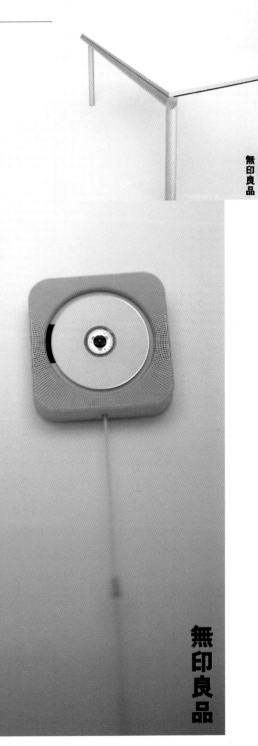

無印良品

無印良品

kanji

early forms		modern character	meaning
🌳 >>> 木		木	tree, wood
🌳🌳 >>> 林		林	woods
🌳🌳🌳 >>> 森		森	forest
🌳 >>> 木		本	root, origin
☉ >>>		日	sun
>>>		月	moon
☉ + >>>		明	bright
〰 >>> 山		山	mountain

kana

hiragana serif	hiragana sans serif	katakana serif	katakana sans serif
あいうえお	あいうえお	アイウエオ	アイウエオ
かきくけこ	かきくけこ	カキクケコ	カキクケコ
さしすせそ	さしすせそ	サシスセソ	サシスセソ
たちつてと	たちつてと	タチツテト	タチツテト
なにぬねの	なにぬねの	ナニヌネノ	ナニヌネノ
はひふへほ	はひふへほ	ハヒフヘホ	ハヒフヘホ
まみむめも	まみむめも	マミムメモ	マミムメモ
や　ゆ　よ	や　ゆ　よ	ヤ　ユ　ヨ	ヤ　ユ　ヨ
らりるれろ	らりるれろ	ラリルレロ	ラリルレロ
わゐ　ゑを	わゐ　ゑを	ワヰ　ヱヲ	ワヰ　ヱヲ
ん	ん	ン	ン

simplicity:
the beauty of the empty vessel

"Simplicity" is a word often used in connection with Japanese graphic design, although the use of the word is not meant to imply a lack of complexity.

In an interview with Maggie Kinser Saiki for international graphic design magazine *Graphis* [1], graphic designer Kenya Hara (✿ see pages 80–95 and ✱ 176–179) uses the word "emptiness" to describe his form of abstraction. Hara, in common with many Japanese artists and designers, uses lack of detail or void spaces around an object in order to leave the interpretation up to the audience. Hara offers the Japanese flag, a red circle against white (often interpreted as the sun) as an example of design that possesses this quality of "emptiness." The symbol has no inherent meaning, but contains many possible meanings (land of the "rising sun" is, of course, the most popular interpretation), which develop in the dialog between the viewer and the image.

Maggie Kinser Saiki compares Hara's work to a Japanese conversation, which, like the tea ceremony, might be considered one of the traditional Japanese arts. Japanese conversations tend to use *ma* (pauses or aural space) in the same way that Hara uses space in his work. "Neither designer nor conversationalist wants to push his ideas on the other party, whether viewer or interlocutor. Hara explains that each party must work to surmise the other's position. This mutual work eliminates three or four steps in the dialogue before the first word is even spoken." [2]

In a lecture given to students in Brooklyn, Hara said: "A vessel full of something, mounted high with whatever it may be, is never as beautiful as one that is empty." [3] He was referring to *ikebana* (flower arranging). In Japan, *ikebana* is a popular art form and a hobby for many Japanese people of all ages, with hundreds of magazines dedicated to it. In *ikebana*, only a few flowers and branches are used, arranged in a way that is not found in nature. The Japanese sensibility sees no beauty in a mass of flowers in a vase. The single flower loses its effect in the mass, and opulence alone is not considered a virtue in an arrangement. Economy in the use of material is at the same time an economy in the use of space.

This balancing act of space and material is also the way many of Japan's most renowned designers seem to work. Use of text, color, and line is restrained, just as the flower arranger sparingly applies the flowers to the vase.

With such aesthetic principles, it seems highly appropriate that Kenya Hara is currently the art director of retail chain Muji, a company with design principles that are deeply rooted in the Japanese art of understatement. Muji stuck steadily to these principles throughout the overstatement of the 1980s and the brand-obsessed 1990s, and is now popular worldwide, particularly in Europe. Muji has 265 stores in Japan, 16 in Great Britain, five in France, three in Hong Kong, two in Singapore, and one in Asia. You can order Muji products online at www.mujionline.com.

Muji is short for *Mujirushi Ryohin*, which means "no label, quality goods." Muji products, which include stationery, furniture, household goods, clothes, and food, are simple and unaffected, both in content and in packaging, fusing Japanese minimalism and simplicity with universal utility and affordability.

By using the same clear cellophane material to wrap pillows, shirts, cookies, and breakfast cereal, Muji makes sure that its consumers can see exactly what they are buying, and that they don't pay for extra design or expensive packaging. All product labels are uniform, listing the contents and nothing more. In some cases, package and label are the same thing: a narrow kraft-paper band. The packaging remains the same in Muji shops around the world.

There is no need to localize, as the premise of the chain's popularity is that the Japanese have very high standards of quality. Even in London, the Muji logo, in Japanese *kanji* script (see page 102), features prominently on packaging, carrier bags, and signage.

One Muji product that perhaps epitomizes the brand is a wall-mounted CD player (✿ see page 95). It has a simple white design and, mimicking a fan, spins an exposed CD that is set in the frame of a built-in speaker. It has only one dial, hidden on top of the unit, which controls the volume. You simply tug on the hanging power cord to turn it on, and tug again to turn it off. Naoto Fukasawa, the designer of the CD player, is a world-renowned product designer who shares the same aesthetic principles as Hara, but to the point of religiosity: "Good design means not leaving traces of the designer and not overworking the design. If you overdo the design it will touch the beholder's consciousness. I think that when people and things are within the boundaries of consciousness they are at their furthest from heaven." [4]

The Japanese generally believe that the large universal themes can be touched only through the sparsest of expressions. This concept is influenced by the Zen Buddhist quest for enlightenment through emptying the mind.

Ikko Tanaka (see page 13), Muji's chief advisor until his death in 2002, was fascinated with Noh theater. He once said that the symbolism and subtlety of Noh, in which elderly characters or ghosts often recall their prime, transforming themselves and the stage with a single gesture, "is the opposite of today's communication." [5] Tanaka was perhaps referring to a fear that, with more and more Westernization, traditional ways of communicating through silence or the simplest of gestures will be overtaken by superfluous action, brash branding, and the swamping of information.

The theme of simplicity extends to all the arts. In Japanese garden design, a large rock will be surrounded by an expanse of gravel—similar to much Japanese graphic design, in which an object is surrounded by empty space.

The most renowned form of Japanese poetry is the *haiku*, a short poem of three lines and just 17 syllables. The *haiku* is very spare in its use of space, time, and the expression of thought and emotion. *Haiku* is not told in the first person and does not directly describe emotions, but uses evocative, concrete imagery that has the power to stir emotions. American beat writer Jack Kerouac, author of *On the Road* (1950), was strongly influenced by the *haiku*. In his book *The Dharma Bums* (1958) one character explains:

"A real *haiku*'s gotta be simple as porridge and yet make you see the real thing, like the greatest *haiku* of them all probably is the one that goes 'The sparrow hops along the veranda, with wet feet,' by Shiki. You see the wet footprints like a vision in your mind and yet in those few words you also see all the rain that's been falling that day and almost smell the wet pine needles." [6]

Graphic designer Shigeo Fukuda is also influenced by the *haiku*, as Maggie Kinser Saiki comments in another issue of *Graphis*:

"By tricking the eyes, and therefore challenging understanding, Fukuda could be said to be carrying on the

traditions of Dalí and Matisse, but his work has a simplicity that he says is Japanese. He says, 'As with the Japanese family crests,'—used on kimonos, gates, and other family possessions—'the effort is toward abridging as far as possible. With abridgement, it becomes stronger.' However, the visual simplicity to which Fukuda is faithful does not necessarily reveal a simplicity in the idea: 'Old pond/frog jumping/the sound of water.' Fukuda likens his 'Victory' poster to *haiku* like this. Given the choice, he says, he prefers a heavy subject. 'I don't know if there's such a thing as a deep laugh and a shallow one, but if there is, I'm after the deep laugh. I think that's why I like *haiku*. It may be just a frog and a pond, and yet, depending on how you think about it, it could be about the universe, or life.'" [7]

The poem quoted by Fukuda is by the great seventeenth-century poet, Basho, who once said: "The *haiku* that reveals 70–80 percent of its subject is good. Those that reveal 50–60 percent we never tire of." [8] This quote is comparable to Kenya Hara's expression about the vessel needing to be empty to be beautiful. Just like a *haiku*, Fukuda's pieces leave the viewer alone to, as he says, "finish the work" him or herself.

Poster designer Makoto Saito tries to create the same effect by rarely using text in his work. Saito has even been known to discard words that have been supplied to him by the copywriter. "I think I started this fad for the text-free poster," he says in one interview. "When ten people look at a poster of mine, they will imagine ten different things. If a hundred people see it, there could be up to a hundred different interpretations." [9] This again has a connection with Zen Buddhism, where silence is valued and language is often seen as an obstacle to understanding.

The Japanese have a very complicated writing system, with more than 50,000 characters. The quantity of characters and their huge variety presents quite a challenge to the Japanese graphic designer, and this has had an inevitable impact on typography and graphic design.

Japanese is written using a combination of three systems: *kanji*, *hiragana*, and *katakana* (these last two are collectively known as *kana*). In the last hundred years or so, a further addition to the language has been *romaji*, the roman script (that is, the alphabet used for English and most other European languages). *Romaji* is often used in advertisements and magazines.

japanese typography

The bulk of Japanese subjects are written in *kanji*. These are characters that emerged in China 5,000 years ago and started as simple pictographs—that is, picture-symbols of the objects they represented. These pictographs were combined to form further words. For example, the pictograph that means "tree" is doubled to express "woods" and tripled to express "forest." A line added to the bottom of the pictograph for "tree" forms a character meaning "root" or "origin." The table on page 96 shows examples of early character forms and their modern counterparts, as well as some character combinations.

Kanji were first introduced to Japan via the Korean peninsula in the fourth century CE, and adopted because the Japanese did not have a writing system of their own.

There are about 50,000 *kanji* characters, so learning *kanji* requires an extraordinary feat of memorization. *Kanji* are used for verbs, adjectives, and nouns. However, Japanese cannot be written entirely in *kanji*. For grammatical endings and words that cannot be written in *kanji*, two other writing systems, *hiragana* and *katakana*, are used.

Hiragana and *katakana* are both 46-character scripts, which when discussed together are called *kana*. Even though one can theoretically write the whole Japanese language in *hiragana*, it is usually used only for the grammatical endings of verbs, nouns, and adjectives, as well as for particles, and for vernacular words. *Hiragana* is the first of all the writing systems to be taught to children, and many books for young children are written in *hiragana* only.

Katakana is used mainly for technical names and for loan words from Western languages, particularly English. The pronunciation of loan words is Japanized, and sometimes sounds quite different from the original pronunciation. For example, "curtain" becomes *kaaten*; "elevator" *elebeetaa*; and "girl" *gaaru*. Many loan words that are not shortened in their original language are abbreviated, for example: *suupaa* (supermarket); *waapuro* (word processor); and *depaato* (department store).

Some "loan words" are actually Japanese creations rather than genuine loan words. For example, "salaryman" is a Japanese word for a typical Japanese company worker, while the "walkman" has found its way back into English dictionaries. [10]

Just as the Japanese accepted, absorbed, and synthesized Chinese culture many centuries ago, in the last century they have adopted Western culture and its language, ideologies, and artefacts. *Romaji* is the writing of the Japanese language in Roman characters as opposed to the usual mix of *kanji* and *kana*. *Romaji* is used for many reasons: street signs for visiting foreigners; the transcription of personal, company, or place names to be used in another language context; dictionaries and textbooks for learners of the language; or simply for typographic emphasis.

Kana are fairly simple characters and usually comprise just a couple of strokes. *Hiragana* are more cursive, while *katakana* are more angular. *Kanji*, on the other hand, are more complex characters and can have between one and 33 strokes. A combination of all three character types, (and sometimes four, if *romaji* is used as well), all of which differ in form, quality of line, and number of strokes, can make the construction of visually pleasing and typographically coherent styles extremely difficult for graphic designers.

Another challenge for the graphic designer is the sheer quantity of characters. Not all of these *kanji* are used in everyday language, however. In 1981, the Council of Japanese Language selected 1,926 *kanji* to be used as "Chinese characters for common use." The Council did not, however, set any regulations as to the use of those remaining. This presents a problem for graphic designers, as described by Tadasu Fukano in his article "Let's start by non-use":

"Taking a newspaper, for example, every press must have available for use at least 8,000 different characters, including *kana* (Japanese characters), the Roman alphabet, and other various symbols, in order to meet the requirement necessary for any comprehensible newspaper. Out of these 8,000 characters, only 3,500 are sufficient enough to cover more than 99 percent included in the entire newspaper. This means

that the remaining 5,000 characters, despite the strenuous work put into them by many designers over a long period of time, are lying idle, except for the few that are used once in a while for proper names and for technical terms. Also, most of such characters are very complicated, entailing many strokes, and are therefore not easily legible to the general public." [11]

Take that total of 8,000 and multiply by each "weight" (light, demi-bold, bold), and you start to get an idea how much work goes into all of this.

Fukano goes on to say that "the astronomical quantity of existing *kanji* is actually inhibiting the development of [Japanese] typography." [12]

His solution is "not to use those characters that are seldom used or are too complicated to read." [13]

Fortunately, since Fukano made his comments in 1982, computer technology has advanced enormously, increasing the speed and ease with which *kanji* can be designed. This new technology, which has been created specifically for Japanese, Chinese, and Korean fonts, is known as stroke-based font technology. However unique every *kanji* character is, certain parts occur again and again, recombining to create new characters. A stroke is a continuous line in a Chinese character, most easily observed when looking at the brushwork in calligraphy. Programs have

been created that break down *kanji* fonts into parts that loosely correspond to brushstrokes. These stroke parts are kept in "parts libraries" that are used to draw each character. By reusing these parts, *kanji* can be created quickly and easily. To create a new *kanji*, you simply use a similar character, swap out the parts that need to be changed, and fine-tune them.

Whereas with Roman script a designer can create a new font independently, Japanese typographers need a huge amount of support to create a full font. Often the work of typographers and graphic designers do not overlap in the same way that they do in the Western world, and usually a graphic designer will design only the letters that are needed for a campaign.

vertical or horizontal?

Traditionally, Japanese is written in vertical columns and is read from right to left. With the arrival of Western influence in the mid- to late 1800s, the Japanese started to experiment with writing horizontally. Today, Japanese text can be read vertically or horizontally. In the media and on signs you will still see a mixture of both ways of writing. In the early years, there was much confusion about whether horizontal writing should be read from left to right, as English is, or right to left, as Japanese is. Following the Second World War, confusion was ended when, under American influence, the government introduced a rule that horizontal writing should read from left to right.

Books and magazines still cause some confusion. When a book or new magazine is launched, there is often a debate about whether the publication opens from right to left, Western style, or left to right, Japanese style. Usually, magazines with Western content open in the Western style.

japlish

"Japlish" is the word used for the decorative use of English words in Japan. English words are often used on stationery, clothing, and advertising. Japlish is English that is often mistranslated from Japanese and ranges from grammatically correct but cloying and sentimental, to comically misspelled, to downright impenetrable. Here are some amusing examples:

- The name of a clothes shop in Harajuku:
 Obscure Desire of Borgeoisie
- On Capsule Children stationery:
 Very wonderfully and more pleasantly
- On a rucksack:
 I like to watch the seasons change.
 It's a precious feeling, like having a rucksack on your back
- On a beer advert:
 Kirin—Beverage of Communication
- On a greetings card:
 I'll sticky about my favorite things
- On a poster advertising a hospital:
 Heartful care
 Kind humanity

english in graphic design

Many graphic designers like using English, not only because it adds a certain cachet or trendiness to a design, but because they enjoy its visual simplicity. And with so many shops and products using English words, it is hard for graphic designers to avoid using English in their work. Many designers welcome this, as design writer Ayako Ishida told me: "It's easier to come up with a cool layout using alphabets that have only a couple of strokes, than the very complicated Chinese characters we use."

She also explains that the use of English in graphic design has much to do with the Japanese love of ambiguity: "We Japanese tend to love things that are indirect, that suggest something rather than clearly explaining it. The use of English words is perfect for that, because almost everybody knows basic English—it is a required subject at middle and high school—but almost everybody does not really understand it well. So, English is a helpful tool to convey a message vaguely and indirectly."

the first bite is with the eye: the art of japanese packaging

A common Japanese saying is "the first bite is with the eye," and Japanese packaging is perhaps the most visually inventive and thoughtful in the world.

In Japan, everything from wine bottles to chopsticks is beautifully wrapped. Journalist Michael Fitzpatrick explains: "To please the demands of the most fastidious consumers in the world, packaging design has adapted accordingly, to the extent that even non-brand names need 'dressing.' Everything demands packaging in Japan— from the humble apple, bought individually wrapped, to luxury items such as Ł200 [$160] melons, lovingly boxed and gift-wrapped. All items must come with an appropriate wrapping, as everything—in Japanese eyes—has value." [14]

The visual and tactile first impression of an object is intensified through the materials and graphics used for the object's packaging. Sometimes the packaging will cost more or be more beautiful than the product it contains.

modern japanese packaging

the menace of convenience

Modern Japanese packaging style is clean, simple, and minimalist. It is rare to see photographs or four-color artwork, and color palettes are distinctive and minimal. In Japanese packaging, "beautiful" does not equate with "overtly decorative" or "elaborate," as Kazumasa Nagai explained in an article entitled "Packaging design in Japan":

"The package can embody certain personal and spiritual values, and not only to serve a material purpose. This attitude is related to the spirit of the tea ceremony or of Zen Buddhism. Perhaps as a result, many traditional Japanese packages display a simple and sober charm rather than being gay or decorative. However expensive the contents may be, they avoid any superficial luxury and seek their beauty in a modest restraint." [15]

In the 1980s, "simple and sober" gave way to graphic overload and packaging became grossly overwrought. Since the economic downturn of the 1990s, there has been some return to understatement, although there is a growing fear that in a new age of "convenience," attention to detail, quality values, and inventiveness are slowly being jettisoned.

Where once the possibilities for beautiful packaging seemed endless, there is concern in some design quarters that the popularity of convenience stores is inhibiting the inventiveness of common food and beverage packaging design.

In Japan, all-night convenience stores such as 7–11 and Lawson are taking over the dark, gloomy stores that were once the only places where Japanese urbanites could buy their groceries. These stores, open 24 hours a day, all year round, have gained huge popularity in the last decade, and there are now more than 50,000 of them. These stores are always brightly illuminated, with large glass doors and windows facing a busy street, not only to discourage robbery, but also to encourage the perception of them as lighthouses—the only quasi-daylight spot in the midst of the dark and cold. Goods are not piled up carelessly, as in many of Japan's small supermarkets, but carefully positioned so that you can slip through the transparent doors and easily pick up anything you like. Burgers and noodles are self-served from a hot counter, and if you have a craving for ice cream in the middle of the night, then you can satisfy your whim here.

As people are getting busier and busier, they are also becoming more impatient, and the success of these shops depends on supplying consumers with the products they want, whenever they want them,

quickly and cheaply. Competition between manufacturers is fierce, and brash packaging is a way to grab consumer attention. In fact, packaging is produced so that it only works in convenience stores, those "brightly lit gladiator's pits of commercial competition" as described by journalist Maggie Kinser Saiki. She goes on to say: "Taking the products out of that context [...] is like seeing a prostitute in a church: in a normal environment they look shockingly garish and scantily attired." [16]

Yasuo Tanaka of Package Land Co. Ltd. says in an interview for *Graphis*: "Package design has been subsumed into the distribution system." [17] Products have only one week in which to succeed. Tanaka believes that digitalization has spawned a slew of "average, as opposed to professional, package design" that depends almost wholly on graphics. Conceptual packaging, or packaging that explores the possibilities of form and construction, are almost nonexistent in these quick-sell venues. Tanaka instead chooses to express himself by experimenting with self-promotional pieces or exhibition packages, most of which are conceptual and impractical in the extreme.

Tanaka believes that in recent years, product area and retail outlet has bifurcated into two extremes, with the package designer caught in the middle. "Uniqlo or Chanel, that's the choice," says Tanaka. [18]

As Maggie Kinser Saiki describes: "Uniqlo is similar to Gap, only cheaper, featuring mostly rough-stitched unisex clothing in warehouse-sized stores." [19] Since economically hard times hit Japan, Uniqlo, along with 100-yen shops, has become hugely popular. With seasonal hit products such as chino slacks and t-shirts, Uniqlo's popularity has remained strong, but like Gap, there are criticisms that the brand is impersonal, uniform, and lacks creativity.

Despite the spread of convenience stores and homogeneous packaging, there are still places where the tradition of beautiful packaging thrives. In recent years, following a dip during the early years of recession, the popularity of food basements in department stores is growing once more. These oases of epicurean indulgence are the places in which to find innovatively packaged food and drinks (often bearing prestigious labels), in unusual boxes often created by inventive folds or in containers made of materials that emphasize shapes in almost sculptural ways. So, although convenience stores have their place, there will always be some space where Japanese people can indulge in their love for beautiful packaging.

The Japanese have a long history of beautiful wrapping. The wrapping (*tsutsumu*) or tying/binding (*musubu*) of objects has special meaning in the context of Japanese ritual and belief, signifying not only enveloping something with a covering but demarcating it as special and sacred. Wrapping is particularly important as part of the ritual of gift-giving, which has been an integral part of Japan's culture for the last 400 years. Modern Japanese people have gift-giving obligations to colleagues, clients, and neighbors, which are mainly fulfilled in two gift-giving seasons: *o-chugen* in the summer, and *o-seibo* at the year-end. Gifts are also presented to neighbors when moving into a new house, or as *o-kaeshi* (return-gifts) for money received at weddings and funerals.

It is considered impolite to carry an unwrapped gift or object; it must always be enveloped in some fashion. The word *tsutsumu* derives from the verb *tsutsushimu*, meaning "to be discreet" and "to show restraint and respect." *Hadaka*, or "naked," is what the Japanese call something without a package or wrapping of some sort. Carrying something unwrapped in public is almost as discourteous as exposing yourself.

In gift-giving, wrapping can be used to symbolize the hierarchical distance between the giver and receiver. Usually, the more layers that are used, the greater the social distance between the

giver and recipient. A gift to an employer, for instance, will be wrapped more elaborately, with more layers, than a gift to a child or a close friend. *Tsusumu* expresses the giver's respect for the recipient and signifies the spirit of giving not only a material object but feeling from the heart.

Wrapping is done very simply, using a minimum of paper and tape. Such care is taken in the wrapping that a giver would feel taken aback if the recipient tore the package apart without a thought for the wrapping. The polite way to open a present, especially in the presence of the giver, is to undo it carefully, without tearing the paper. Some recipients neatly fold the paper, saving it for reuse.

Color symbolism is important when it comes to wrapping material. Red, for example, symbolizes life and vitality, and is usually the color of wrapping a gift for a happy occasion such as a wedding or a birth. White, representing purity or cleanliness, is often used in combination with other colors to ward off misfortune. Gifts wrapped in black (which represents death) and white indicate a gift for an unlucky or unfortunate occasion, such as a funeral.

There are many other meanings to be found in the types and patterns of the paper, the direction of the paper's motif, and the type of binding used for wrapping. *Mizuhiki*, a special type of string

made from mulberry bark, is sometimes used, with knots tied in the cord to symbolize the relationship between the giver and recipient. Certain types of knots, which cannot be untied, mark events that occur only once in an individual's lifetime, such as a wedding or a funeral.

Noshi is another tradition in wrapping. Originally, *noshi* referred to a strip of dried abalone that was folded in heavy red or red and white paper and given as a gift to signify good fortune (because Buddhist tradition forbids the eating of flesh at sad times). Nowadays, instead of real abalone, a symbolic yellow strip of paper or plastic is used, or paper and envelopes printed with a *noshi* design.

Once gifts have been wrapped, they are often placed in an attractively decorated box, which is itself wrapped in a *furoshiki* until presented directly to the recipient. *Furoshiki* is the Japanese version of a carryall bag. It is a square piece of cloth, portable and unobtrusive, that can be as small as a napkin, a full yard square, or anywhere in between. When its corners are all tied, it forms a bag with handles. *Furoshikis* were originally used to carry towels to public bath-houses and were spread on the floor to stand on, like a bathmat, while drying.

Gifts of cash continue to be common in Japan, particularly at *otoshidama* (New Year), when

money is given to children. The small gift envelopes (*pochi-bukuro*) are decorated with a variety of patterns, such as flowers, or one of the 12 animals from the Chinese zodiac. When the Japanese stay in high-class hotels, they like to leave tips in decorative *pochi-bukuro*.

Once it was common to carry presents directly to the person in their home, but today, the normal pattern is to have the gifts wrapped and delivered by a department store. Seasonal gift-giving is becoming less common among the younger generations, who tend to think of the practice as empty and old-fashioned. Nonetheless, gift-giving is still vigorously continued by many people throughout Japan.

manga

history
and
influence

Manga (Japanese comics) is a hugely popular visual medium in Japan, and one from which many graphic designers often borrow motifs. Many successful *manga* go on to be made into *anime* (animated television serials or movies).

Manga comics and books account for 23 percent of total publication sales in Japan, and the most popular weekly comic has a circulation of 3.5 million copies.[20] Published weekly or monthly as telephone directory-sized books, *manga* comics are read by adults and children alike.

Many Westerners have the misconception that *manga* is a comic genre depicting excessive sex and violence. This is not true. Although *manga* with explicit sexual and violent content is widely read, *manga* encompasses many genres. As well as stories of the criminal underworld, there are *manga* devoted to much tamer themes such as day-to-day life at a gym, golf, fishing, or cooking. In the early 1980s, *Comic Morning*, a bi-weekly aimed at middle-aged white-collar workers, imparted information on the stock market. Recommendations by its author, Jiro, a stock market analyst, could influence stock prices. [21]

Some Japanese academics argue that *manga* has stylistic origins as far back in Japanese history as the sixth and seventh centuries CE, when Buddhism was being introduced and many temples were being built. On two of these

temples, Toshodaiji and Horyuji, the earliest examples of Japanese caricature have been found. Narrative picture scrolls from the twelfth century are often referred to as examples of the oldest surviving Japanese comics. These scrolls run continually without frames, and changes in time, place, and mood are shown by mist, cherry blossoms, maple leaves, and other commonly understood symbols. Renowned examples include scrolls narrating *The Tale of Genji*, a novel written by a twelfth-century court woman, and the *Chojugiga* scrolls (the "Animal" scrolls) by the artist-priest Toba, which satirize the Buddhist clergy and the nobility.

Artist Takashi Murakami (✷ see page 194) has made a name for himself linking the two-dimensional aspects of *manga* with *ukiyo-e* (see pages 9–10). By emphasizing this link, he also shrewdly confers artistic status and historic relevance onto his own work, which uses *manga* and *anime* motifs. He has even coined the term "superflat" to describe his self-generated artistic movement. Murakami's images borrow from the glossy transgender and sexual explicitness of *manga*. His characters' large eyes are also a motif taken from *manga*.

The biggest influence on the proliferation of *manga* was post-war imports of European and American comic books and animation, particularly that of Walt Disney. Osamu Tezuka was one of the original *manga* artists responsible for the explosion in comics. When he died in 1989, Tezuka left behind more than 150,000 strips, several very influential *anime* (*Astro Boy* being among the best-known), and *manga* masterpieces such as *Buddha*. Tezuka, who was born in 1928, was heavily influenced by Disney (he admitted to watching *Bambi* 80 times and *Snow White* 50 times) and the Fleischer Brothers (creators of Koko the Clown and Betty Boop). This influence may also have worked the other way. Although Disney claims it knew nothing about Osamu Tezuka's television animation *Kimba the White Lion*, which aired in Japan in 1965, there are many similarities between it and Disney's *Lion King* stories, which were made in 1994, 1998, and 2004. For example, Disney's lion is called Simba; Tezuka's Kimba. In both animations, a wise lion king is killed and a young prince is forced to leave home, to return later to find the throne occupied by a tough, elderly lion with a scar over one eye. Tezuka's wife allegedly decided not to file suit against Disney (Tezuka died before the Disney film came out), because she knew how much Disney had influnced her husband's work.

One of the attributes that Tezuka borrowed from Disney, and one that continues to pervade Japanese visual culture, is characters with large eyes. Tezuka noted how Bambi's childish attributes, such as his big eyes and large head, were an ideal way of conveying complex emotions.

Despite Western post-war influences, *manga* still possesses qualities that are distinctly Japanese. These qualities link to the concepts of simplicity, emptiness, and abstraction explored earlier in this book. In *manga*, there can be pages and pages of images without text. The image alone, either in isolation or in sequence, conveys narrative information. Such absence of text might seem striking and even avant-garde to many European and American readers. However, in Japan, to "read" *manga* is to read images. The story's tension and atmosphere is often conveyed not through words but through a variation in the number of plates per page. Often American and European comics have an extra textual layer that directs narrative—for instance, plates captioned with "The following morning…" or "Later that afternoon…." In such comics, there is an authorial voice that helps the reader understand the images. In *manga*, there is no mediator; the reader has to do all the work.

The image's narrative potential is used to the full, and text appears only within dialog or thought bubbles, except for loose words expressing onomatopeia. *Manga* also uses visual codes and symbols that work as metaphors for emotions that only regular readers of *manga* can interpret.

For example, a large sweat drop on the back of the head displays embarrassment; a balloon of mucus from the nose means the character is asleep; blood gushing from the nostrils means the character is sexually excited; and if petals float from one character to another it's a sign of them falling in love.

Similar, distinctly Japanese, characteristics extend to *anime*. In *Japan Echo* magazine, Okado Toshio writes "With Disney movies, what you see on the screen is what you get, meaning that the image on the screen is complete. With Japanese *anime*, however, what you see on the screen is not a representation but a metaphor. The work is made complete within the mind of the viewer, who is also playing a creative role." [22]

Often, *anime* need to be modified, and not only through language, so that they will be understood abroad. Silence is used in the same way that blank space is used in Japanese art or pauses in traditional Japanese music. Stuart Levy, an American who founded Tokyopop, a company that imports *anime* and *manga* comics to the US each month, said in an interview: "The Japanese have a different perspective on silence, whether it's in music, in speech or even in a meeting. Silence can be just as important and can say as much as sound. There can be something really loud happening and then all of a sudden dead silence, but to an American that's

weird. In [an *anime* film] we'll do what's called 'sweetening' and add in different sound effects and different music and different lines to fill the silence for America." [23]

There is no sign of the *manga* and *anime* phenomenon diminishing in Japan. It is only likely to grow as it continues to reach more audiences worldwide.

1 Maggie Kinser Saiki (2002) interview with Kenya Hara. *Graphis* issue 340.
2 *ibid*.
3 *ibid*.
4 Naoto Fukasawa, www.ideo.com
5 Maggie Kinser Saiki (1999) interview with Ikko Tanaka. *Graphis* issue 321.
6 Jack Kerouac (first published 1958) *The Dharma Bums* p59. Penguin (1976 edition).
7 Maggie Kinser Saiki (1998) interview with Shigeo Fukuda. *Graphis* issue 317.
8 Quoted on p103 in *Collected Haiku Theory* (1951) ed. T. Komiya and S. Yokozawa. 3rd edition. Tokyo: Iwanami.
9 Interview with Makoto Saito by Jan Kubasiewicz and Elizabeth Resnick. *Eye* magazine volume 9 spring 2000.
10 Examples from www.japan-guide.com
11 Tadasu Fukano (1982) "Let's start by non-use." *Typography in Japan* p130. Seibundo Shinkosho Publishing Co. Ltd.
12 *ibid*. p130.
13 *ibid*. p130.
14 Michael Fitzpatrick (2002) "Easter promise." *Graphics International* issue 91.
15 Kazumasa Nagai (1968) "Packaging design in Japan." *Graphis* issue 168/169.
16 Maggie Kinser Saiki (2003) interview with Yasuo Tanaka. *Graphis* issue 343.
17 *ibid*.
18 *ibid*.
19 *ibid*.
20 Facts and Figures of Japan booklet (2003) p134. Foreign Press Center Japan.
21 As discussed by Fred Schodt (1986) *Manga! Manga! The World of Japanese Comics* p152. Kodansha.
22 Susan Napier and Okado Toshio "Japanese *anime* and its American fans." *Japan Echo*, 8 August 2003 p22.
23 Michael T. Jarvis, "The Godzilla-sized appeal of Japan's pop culture." *LA Times Magazine*, 26 October 2003.

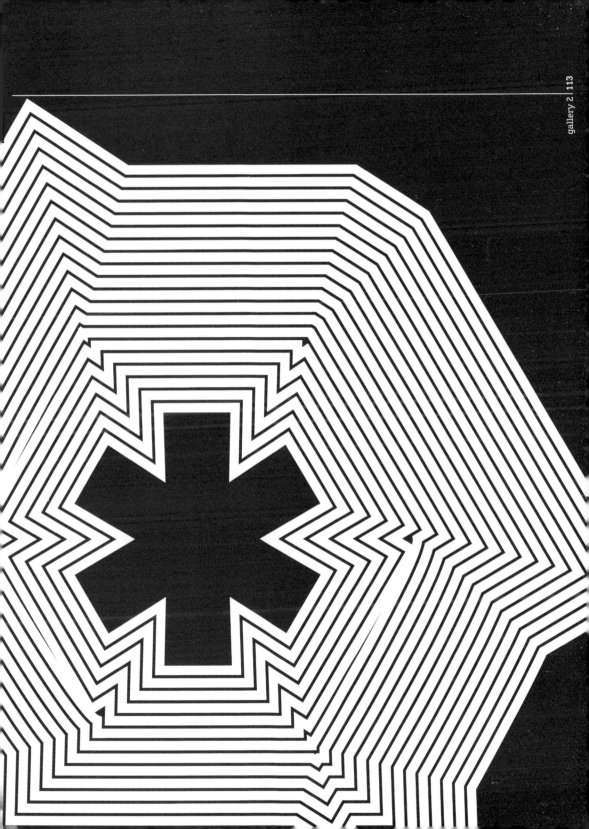

below + right
signage
design agency: Hiromura
Design Office
client: Saitama Prefectural
University
designer: Masaaki
Hiromura
photographer: Takayama
Kozo

Masaaki Hiromura is one of Japan's most significant sign designers. His signage often has an architectural presence, giving character and a human presence to what are often quite stark, modern structures. Here, floor plans and directions are created partly by emphasizing the surface of the glass and concrete substance of the structure.

left + below
signage
design agency: Hiromura
Design Office
client: Tokyo Weld
Technical Center
designer: Masaaki
Hiromura
photographer: Takayama
Kozo

right
signage
design agency: Hiromura
Design Office
client: Tokyo Stock
Exchange Arrows
designer: Masaaki
Hiromura
photographer: Asakawa
Satoshi

The signage for this glass-walled computer-related research laboratory allows for—and draws attention to—the transparency of the building.

This space plays host to Japanese securities markets-related events. Signage taps into the theme of light, speed, and movement, expressing this as a place that is modern, pioneering, and constantly evolving.

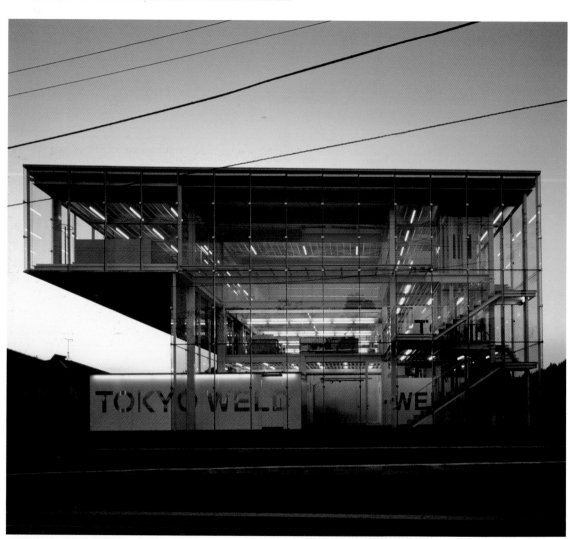

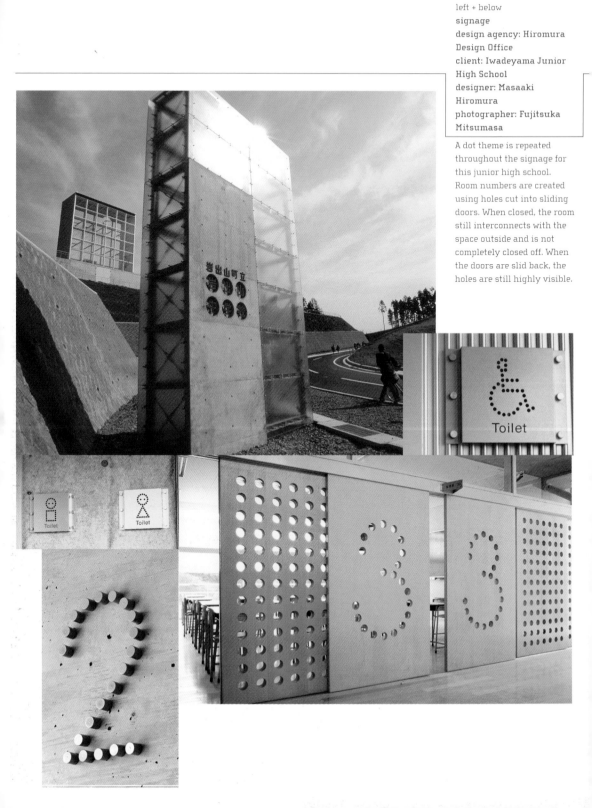

left + below
signage
design agency: Hiromura
Design Office
client: Iwadeyama Junior
High School
designer: Masaaki
Hiromura
photographer: Fujitsuka
Mitsumasa

A dot theme is repeated
throughout the signage for
this junior high school.
Room numbers are created
using holes cut into sliding
doors. When closed, the room
still interconnects with the
space outside and is not
completely closed off. When
the doors are slid back, the
holes are still highly visible.

right + below
signage
design agency: Hiromura
Design Office
client: Big Heart Izumo
designer: Masaaki
Hiromura
photographer: Hirai
Hiroyuki

Signage for this performance space was painted directly on glass or on doors in the form of *kanji* that read, for example, "reception" or "loading bay." The signs provide information but also add decoration to what would otherwise be a purely functional space.

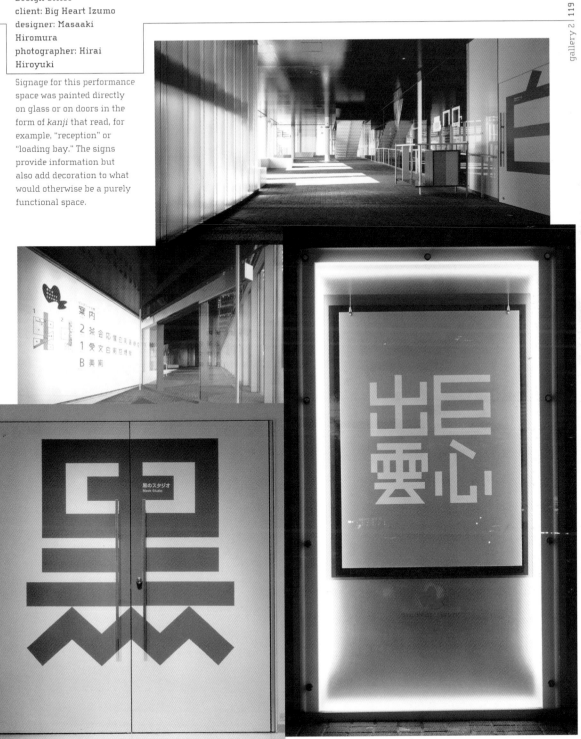

right + below
signage/exhibition design
design agency: Hiromura
Design Office
client: Japanese & Living
Kutsu-Nugi
designer: Masaaki
Hiromura

Kutsu-nugi is a stone used
for removing shoes before
entering a tearoom. An
illustration of feet welcomes
visitors to the exhibition,
and information is placed on
the floor so you look toward
your feet to read it.

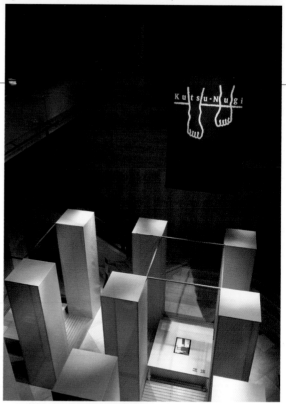

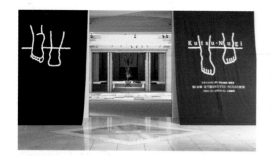

right + below
visual identity and signage
design agency: Hiromura Design Office
client: National Museum of Emerging Science and Innovation
designer: Masaaki Hiromura
photographer: Nakamichi Jun (Nacasa & Partners)

Here, information on the floor guides visitors around the museum, so that the transparency of the architecture is not disturbed and the viewing of exhibits not interfered with.

✱ see page 6
below + right
identity
design agency: Barnbrook
Associates
client: Roppongi Hills/Mori
art director: Jonathan
Barnbrook

The six circles in the
Roppongi Hills logo were
abstracted from the *kanji*
characters for Roppongi,
which translates as "six
trees." The design is not
limited to one fixed pattern,
but consists of a series of
logos (two main logos and
four sub-logos), with
changing typographical
styles around the six circles.

roppongi hills: kanji characters

六本木 ヒルズ゛ =

 six trees

= ○ ○ ○ ○ ○
○

six circles as basic logo

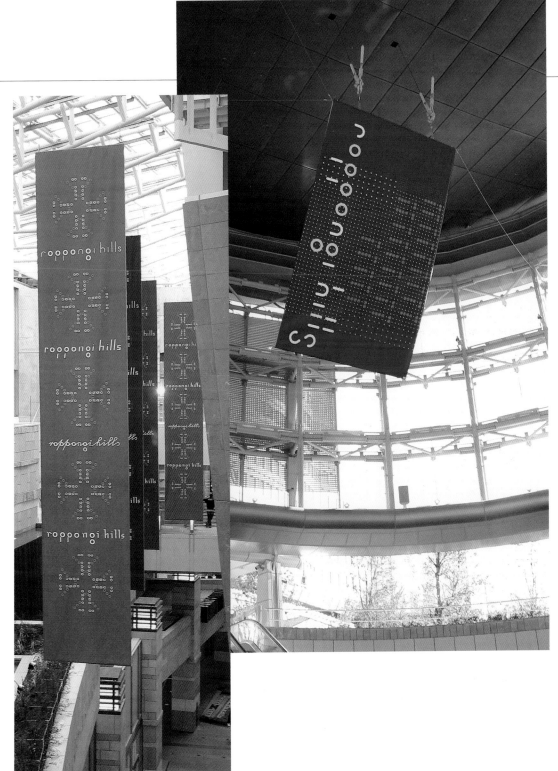

✱ see page 6
right
identity
design agency: Barnbrook
Associates
client: Mori Arts Centre
art director: Jonathan
Barnbrook

Mori Arts Center
incorporates the Mori
Art Museum, Tokyo City
View and Sky Deck (an
observation deck), the
Roppongi Hills Club, and
Roppongi Academy Hills.
A logo was needed for each
separate entity, as well as
one that combined all.

TOKYO SKY DECK

MORI ARTS CENTER

MORI ART MUSEUM

MORI ARTS CENTER

TOKYO CITY VIEW

MORI ARTS CENTER

ROPPONGI HILLS CLUB

MORI ARTS CENTER

ROPPONGI ACADEMY HILLS

MORI ARTS CENTER

MORI ARTS CENTER

* see page 6
left + below
watch, textile design, font
design agency: Barnbrook
Associates
client: Beams
art director: Jonathan
Barnbrook

Barnbrook produced posters,
textiles, t-shirts, and a watch
for the fashion retailer
Beams. He created a typeface
for Beams' advertising by
reworking his own Bastard
and Newspeak fonts into
katakana characters.

✱ see page 128
below
font
design agency: Graph
client: self-initiated

Graph created this font for
their 2003 calendar.

O I 2 3 4 5 6 7 8 9

A A A A A B C C D E E E F

G J J J L M M N N N O O P P

R R S T U U U V Y

A PR

S	M	T	W	T	F	S
		I	2	3	4	5
6	7	8	9	I O	I I	I 2
I 3	I 4	I 5	I 6	I 7	I 8	I 9
2 O	2 I	2 2	2 3	2 4	2 5	2 6
2 7	2 8	2 9	3 O			

✷ see page 5
below
greeting postcard
design agency: Graph
client: self-initiated

In this summer greeting
postcard, the English
syllable "NA" and the
Japanese *hiragana* (see
page 103) "つ" is combined
to read *natsu*, which
means "summer."

below
self-promotional artwork
design agency: Dainippon
Type Organization

Dainippon contributed
these skateboards to the
Tokyo exhibition *Sk8 on
the Wall*, which was
devoted to promoting
"the skateboard deck
as a canvas."

below
promotional artwork
design agency: Dainippon
Type Organization
client: Levi's N3BP

This promotional artwork
was created for Levi's N3BP—
a street gallery opened by
the famous clothing brand.

below
graphics for a t-shirt
design agency: Dainippon
Type Organization

This design for a t-shirt
was created as a tribute
to Japanese *manga* artist
Shigeru Sugiura.

below
self-initiated piece
design agency: Dainippon
Type Organization

Here, English text is
played around with
against backdrops of
different colors.

below + right
t-shirt
design agency: Dainippon
Type Organization

Letters on this t-shirt appear
to be created from a fusion
of *kana* and roman text.

below
promotional artwork
design agency: Dainippon
Type Organization
client: Asami Imajuku

This artwork was designed as a promotional piece for fashion model Asami Imajuku. The *kanji* are translated into English and also interpreted in the pattern and color on which they are laid out.

winter

dandelion

designed

below + right
book
design agency: Dainippon
Type Organization
client: Self-initiated

This book provides users
with the opportunity to
play around with fonts
and discover the many
visual possibilities inherent
in the shape of each letter.

logos
design agency: Ken
Miki & Associates
art director/designer:
Ken Miki

These logos are typical of
Japanese design, created
from bright, solid color,
utilizing geometric shapes,
lacking shadow or outline,
and simply suspended
against white.

KSC Kamoike Bild

Nishinomiya Kurakuen Project

Abilit

Hokusetu (Snow Mountain) paper
for Heiwa Paper Co. Ltd.

Sumikawa Orthopedic Clinic

Paper Voice Gallery

below
illustration
design agency: Ken Miki
& Associates
client: Arjo Wiggins
art director/designer:
Ken Miki

right
illustration
design agency: Ken
Miki & Associates
client: World Environment
Day/United Nations
art director/designer:
Ken Miki

A cute illustration for paper
company Arjo Wiggins.

Silhouetted shapes of
animals, including man, are
neatly fitted into a circle, the
shape of our planet, to
symbolize how we are all
ecologically co-dependent.

left + below
symbol
design agency: Ken Miki & Associates
client: Type Hospital
art director/designer: Ken Miki

This symbol, for a company called Type Hospital, is formed by playing with the possibilities of linking, sharing, and rotating the glyphs of the letters "T" and "H."

below + right
book design
design agency: Ken
Miki & Associates
client: Heiwa Paper Co. Ltd.
art director/designer:
Ken Miki

Simplicity is the strength
of these illustrations.
A limited color palette and
the absence of borders or
shading create an almost
logo-like impact.

h iwa

はじめまして。またひとつ。つながりましたね。

ここからが。また。次のはじまりです。

どんなものさしを持ってますか.

きょうは何回，深呼吸しましたか.

みんなおなじ風を感じているんですね.

目を閉じると，たくさんの声が聞こえてきます.

IBM Design

from Japan

amus arts press

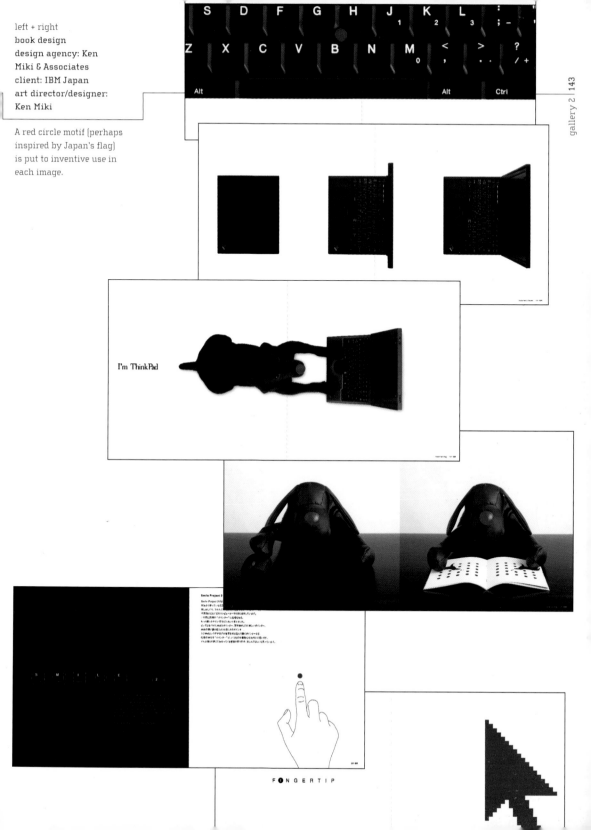

left + right
book design
design agency: Ken
Miki & Associates
client: IBM Japan
art director/designer:
Ken Miki

A red circle motif (perhaps
inspired by Japan's flag)
is put to inventive use in
each image.

I'm ThinkPad

F０NGERTIP

below
identity
design agency: Enterprise
IG Japan
client: Japan Aerospace
Exploration Agency
creative director: Hidetaka
Matsunaga
designers: Kosuke
Hashijima, Ken Yoshihara,
Hidetaka Matsunaga

In this logo for Japan
Aerospace Exploration
Agency (JAXA), the letter "A"
of "Aerospace" has been
arranged in a star-shaped
motif to symbolize "hope",
"pride," and "inquiry."

below
identity
design agency: Landor
Associates
client: Japan Airlines

Japan Airline's JAL marque,
reaching dynamically to
the sky, is partly derived
(as are many Japanese
marques aimed at
international audiences)
from the motif of the
national flag's rising sun.

below
anniversary logo
design agency: Enterprise
IG Japan
client: Boeing
creative director: Hidetaka
Matsunaga, Richard Stein
designers: Hisane Suzuki,
Rina Tanaka, Hidetaka
Matsunaga

Another example of a logo
incorporating Japan's
rising sun motif. Here it
emphasizes Boeing's
Japanese heritage, while
borrowing internationally
recognizable elements of
an existing symbol.

Boeing in **Japan**

conference identity
design agency: Ken Miki
& Associates
client: Icograda
(International Council of
Graphic Design
Associations)
designer: Ken Miki

Brochures, name cards,
banners, etc, for Icograda's
2003 congress in Japan had
a minimal palette of just
two colors—the popular red
and white—as well as the
recurring motif of the red
circle, reminiscent of the
Japanese flag.

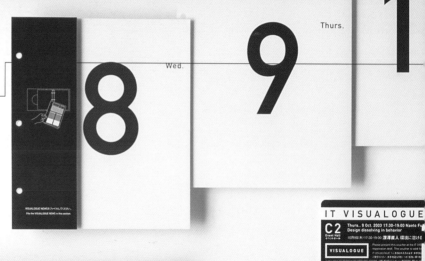

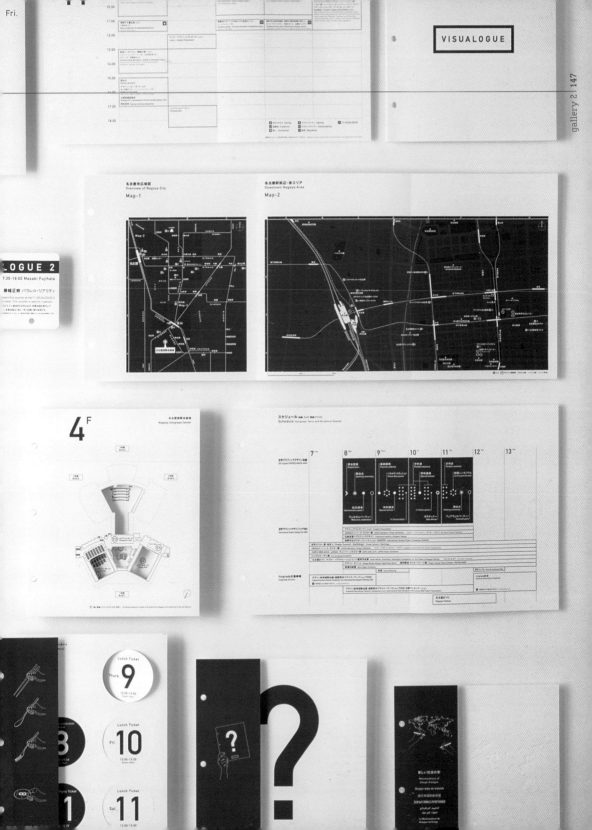

below left
bag
designer: Akio Okumura
client: Human Intellect

below right
packaging
designer: Akio Okumura
client: Kahala

bottom
packaging
designer: Akio Okumura
client: By Man By Woman

Abstract symbols, white, and black, all come together to create a sophisticated look for this bag.

Ink-free debossing on these boxes creates a simple, elegant effect.

Intriguing tubes must be unrolled and paper torn to discover what goods lie inside these packages.

below
bag
designer: Akio Okumura
client: Oji Paper
Gallery Osaka

When these bags are put
side by side, the graphic
symbols (which include
the ubiquitous red circle)
read OPGO, the initials
of the gallery that
commissioned them.

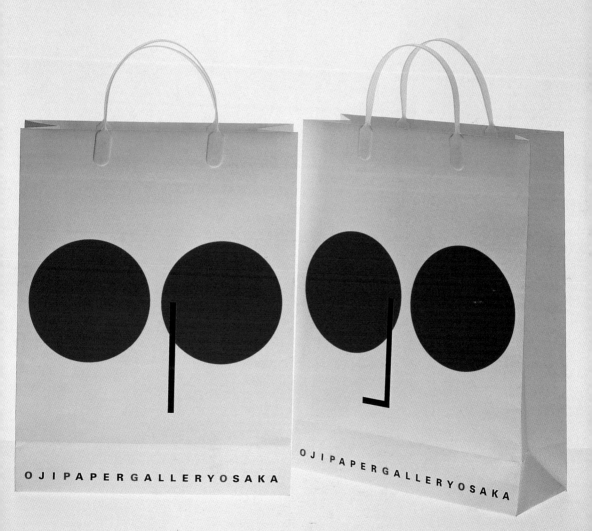

A simple bottle is
transformed into an object
of desire by the slender,
elegant curves of a box that
both reveals and protects it.

below + right
bottle labels
designer: Akio Okumura
client: Nama Sake

A limited color palette and
kanji characters (see page
103) are used to illustrate
this sake bottle label in
a minimal, modern way.

✱ see page 5

below
bottle label
design agency: Graph
client: Fukunishiki
art director:
Issay Kitagawa

right
packaging
designer: Akio Okumura
client: Gekeikan Sake

Letters of the word *ucu*, which means "to float," feature on this bottle label. The idea, according to the sake company, is that "those who drink this sake will be floating in another world."

The color palette, boxing, and font used to package this sake make it look like a mystical potion from an ancient civilization.

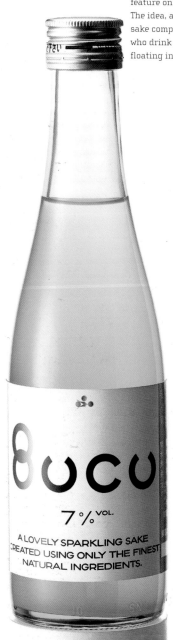

UCU

7% VOL.

A LOVELY SPARKLING SAKE CREATED USING ONLY THE FINEST NATURAL INGREDIENTS.

✳ see page 5
below
packaging
design agency: Curiosity
client: Park Hyatt Hotel

This, at first apparently
seamless, box has a clever,
minimalist sliding cover.

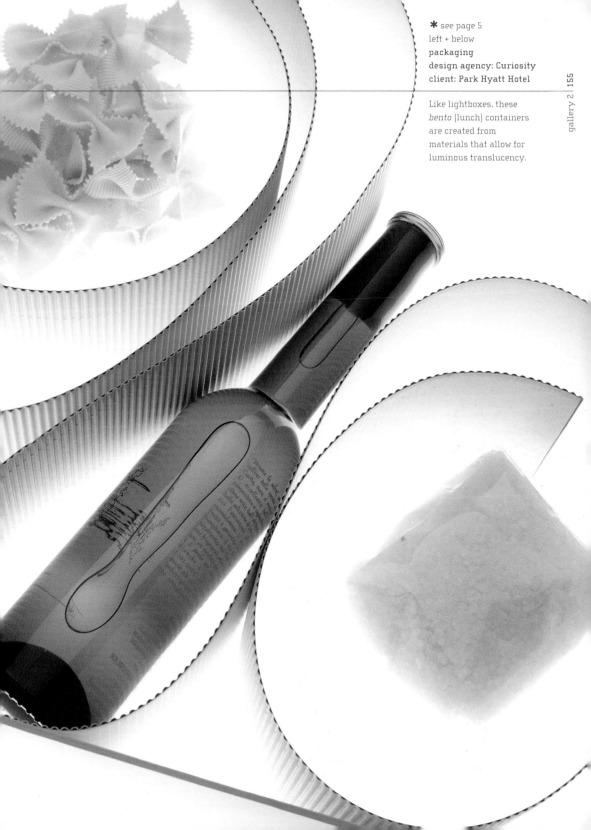

***** see page 5

left + below
packaging
design agency: Curiosity
client: Park Hyatt Hotel

Like lightboxes, these
bento (lunch) containers
are created from
materials that allow for
luminous translucency.

* see page 5
below
book design
design agency: Curiosity
client: Takashi Murakami

Artist Takashi Murakami
never does things by halves;
his children's book is taller
than most six-year-olds and
sits upright on the floor,
fanning into a circle.

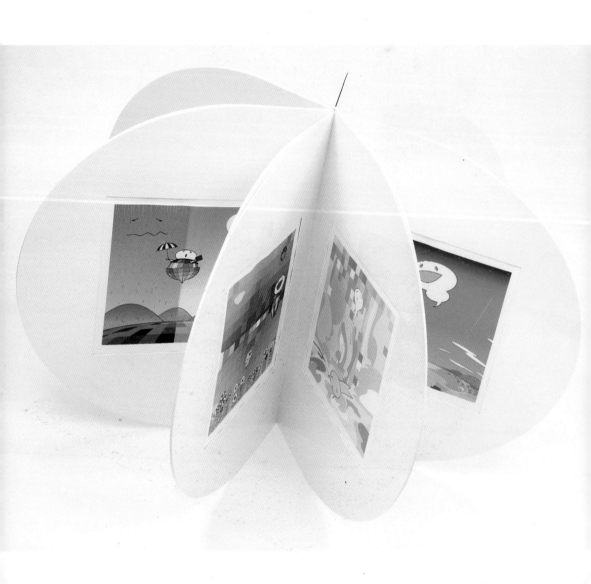

✱ see page 5
below
invitation
design agency: Curiosity
client: Louis Vuitton

The launch of a Louis
Vuitton shop in Tokyo in
2002 was an exclusive
event, and one that
warranted a beautiful
invitation that would be
treasured by recipients.

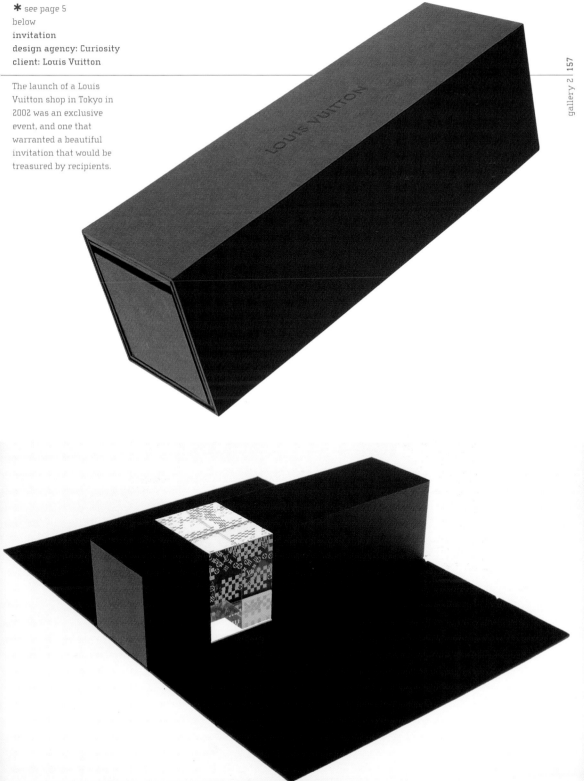

✱ see page 5
below
perfume bottle
design agency: Curiosity
client: Van Cleef and Arpels

✱ see page 5
bottom
perfume bottle
design agency: Curiosity
client: self-initiated

✱ see page 5
left
perfume bottle
design agency: Curiosity
client: Jean-Paul Gaultier

Curiosity's Van Cleef and Arpels perfume bottle is shaped to perfectly fit whatever hand is holding it.

Curiosity not only designed this striking bottle, they also created the scent—Parfum Curiosity—contained within.

Gaultier perfume bottles, like his clothes, tend to tell a story. The blue handgrips that flank this dumb-bell-inspired bottle tell us that the user of this perfume is a man who likes to preen himself, to look good, and smell fine.

✳ see page 5

left + below
cosmetics packaging
design agency: Curiosity
client: Kanebo

This minimalist packaging
beautifully evokes ideas of
cleanliness and purity.

EQUILIR

AROMATIC BODY MILK

木

EQUILIR

AROMATIC BODY WASH

土

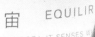

COMFORTABLE BODY VEIL

宙 EQUILIR

LISTEN TO YOUR NOSE IT SENSES W

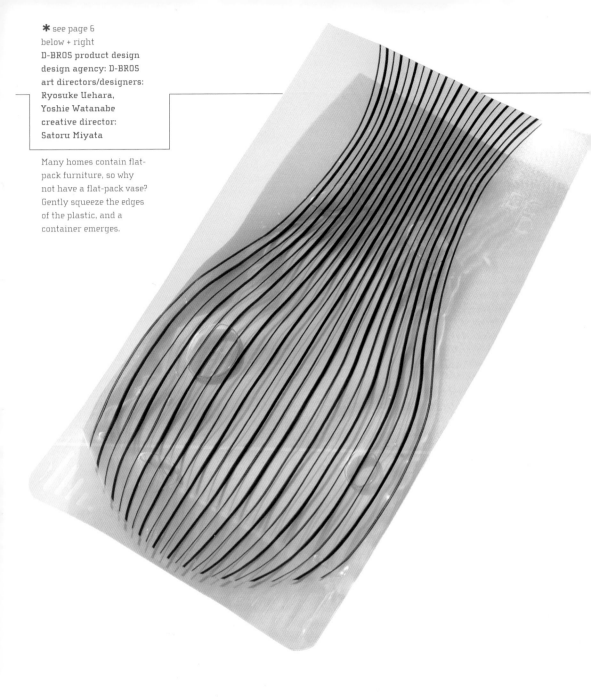

✱ see page 6
below + right
D-BROS product design
design agency: D-BROS
art directors/designers:
Ryosuke Uehara,
Yoshie Watanabe
creative director:
Satoru Miyata

Many homes contain flat-
pack furniture, so why
not have a flat-pack vase?
Gently squeeze the edges
of the plastic, and a
container emerges.

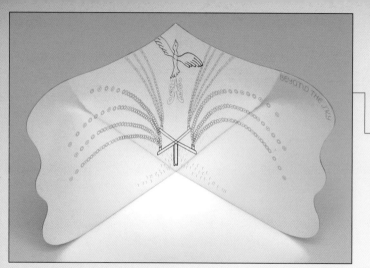

✳ see page 6
left
D-BROS greeting card
design agency: D-BROS
art director/designer:
Yoshie Watanabe
creative director:
Satoru Miyata

Mirrored surfaces within
this greeting card add
an extra dimension to
the illustration.

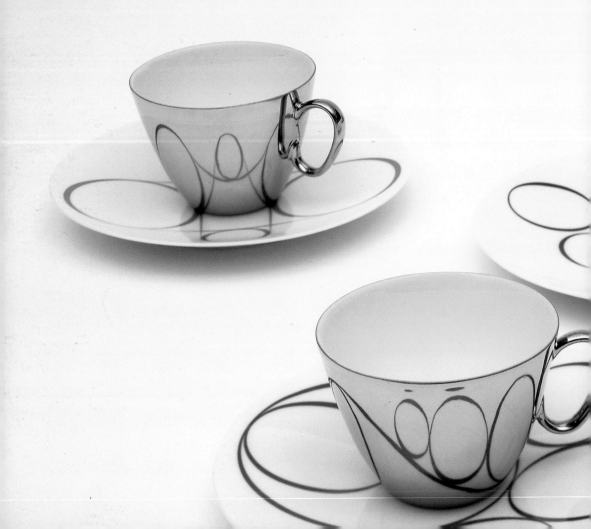

✱ see page 6

below
D-BROS cups and saucers
design agency: D-BROS
art directors/designers:
Ryosuke Uehara,
Yoshie Watanabe
creative director:
Satoru Miyata

The patterns on these
saucers spring into life
against the reflective
surfaces of the cups.

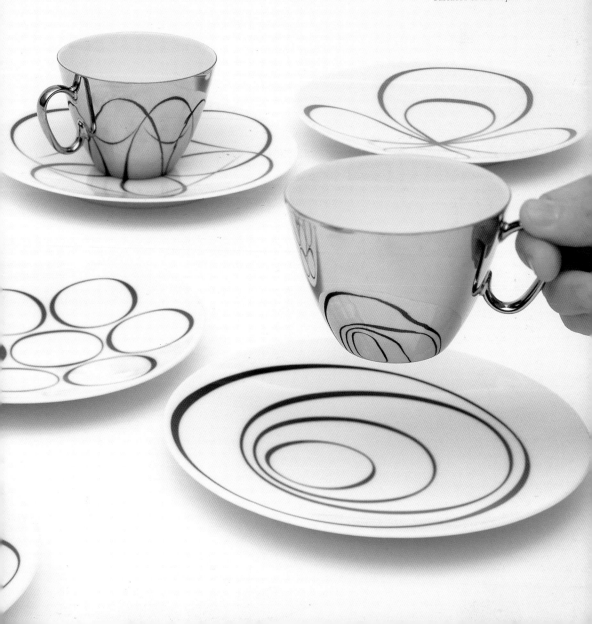

✱ see page 6

below + right
book design
design agency: D-BROS
art director/designer:
Yoshie Watanabe
creator: Chiaki Kasahara

In these books, each page
is cleverly cut to create
an image belonging to
a three- rather than a
two-dimensional world. An
illustrated butterfly (below)
hovers near a flower with
many petals, while an
illustrated dog (right)
bounds up a staircase.

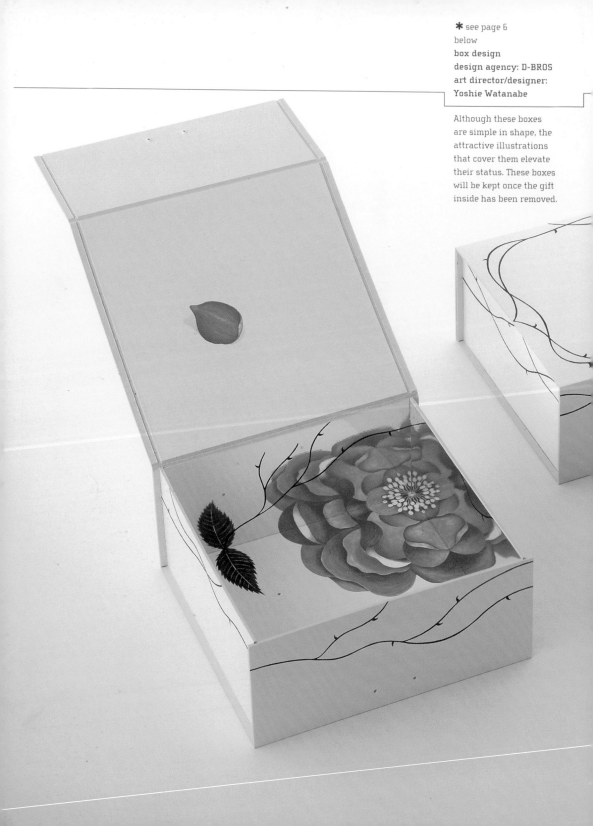

✱ see page 6

below
box design
design agency: D-BROS
art director/designer:
Yoshie Watanabe

Although these boxes
are simple in shape, the
attractive illustrations
that cover them elevate
their status. These boxes
will be kept once the gift
inside has been removed.

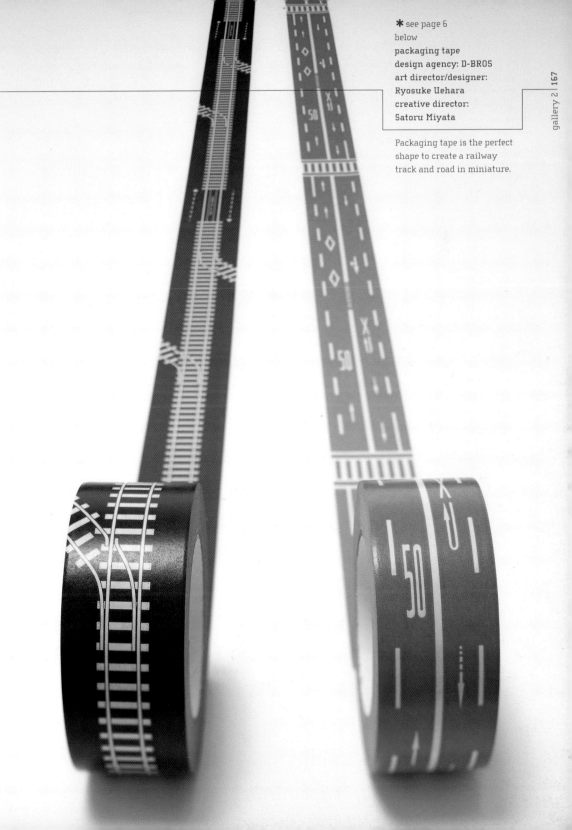

✱ see page 6

below
packaging tape
design agency: D-BROS
art director/designer:
Ryosuke Uehara
creative director:
Satoru Miyata

Packaging tape is the perfect
shape to create a railway
track and road in miniature.

✱ see page 6
below
paper sample
design agency: D-BROS
client: Takeo
art director/designer:
Ryosuke Uehara

The heavy-weighted sheets
of this paper sample are die-
cut into the shape of a dog,
and together stand up to
make the receiver's very own
pet corgi. And if that's not
enough inventiveness, each
sheet is made up of puzzle
pieces that can come apart.

✳ see page 6
left **calendar**
right **Christmas card**
bottom **invitation**
design agency: **D-BROS**
art director/designer:
Ryosuke Uehara

Japanese design is not always about cleanliness, geometricity, minimalism, and modernity. Here, die-cutting, the overlapping of different weighted papers, and translucency, as well as printing with different gloss effects, creates pieces with lots of character and texture. D-BROS has even dared to create work that intentionally looks battered, aged, and faded.

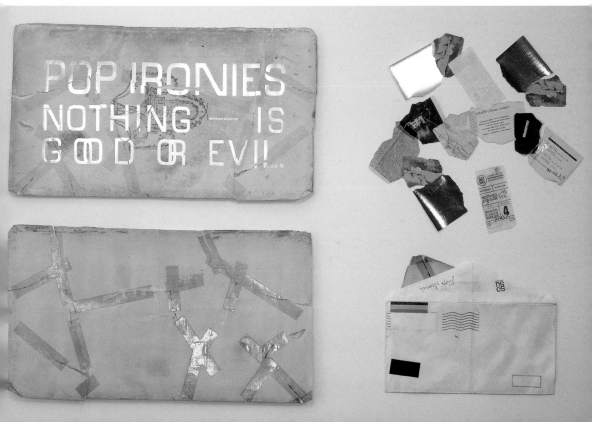

✳ see page 6
below
notebooks
design agency: D-BROS
art director/designer:
Ryosuke Uehara
creative director:
Satoru Miyata

The illustration at the
edge of each page of
these notebooks is die-
cut in a different place.
Consequently, pages nearer
the top contain less of the
image than those at the
bottom, but all fall together
to create a tilted, and more
three-dimensional, version
of the whole.

✳ see page 6
right
paper chair
design agency: D-BROS
art director/designer:
Ryosuke Uehara

Here, each page is cut in the
shape of a chair in profile,
so that when many are
stuck together, an actual
sitting-up, solid chair is
formed. D-BROS' innovative
paper engineering proves
that books don't just have
to lie flat on a desk or stand
on a shelf; they can also
exist as ornaments of
different shapes.

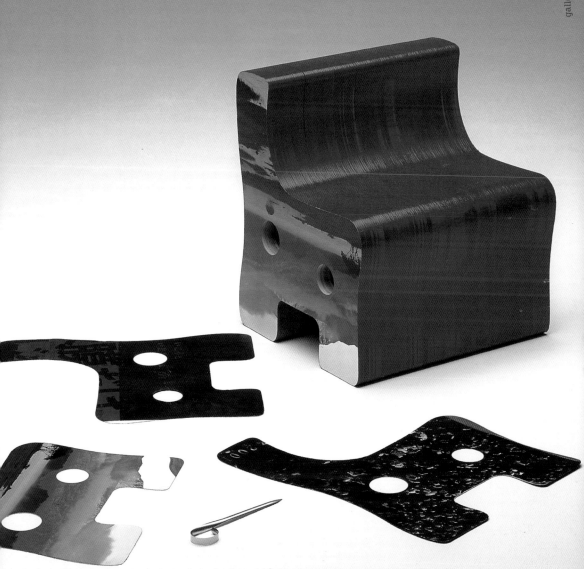

* see page 6
below
greeting cards
design agency: D-BROS
art directors/designers:
Yoshie Watanabe,
Ryosuke Uehara
creative director:
Satoru Miyata

The designers at D-BROS
are true masters of paper
engineering. These adorable
animal-themed greeting
cards cannot fail to charm
and inspire.

* see page 6
below
fabric
design agency: D-BROS
art director/designer:
Yoshie Watanabe
creative director:
Satoru Miyata

As well as crockery sets,
vases, and innovative three-
dimensional paper objects,
D-BROS have designed their
own range of fabric.

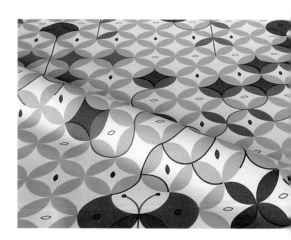

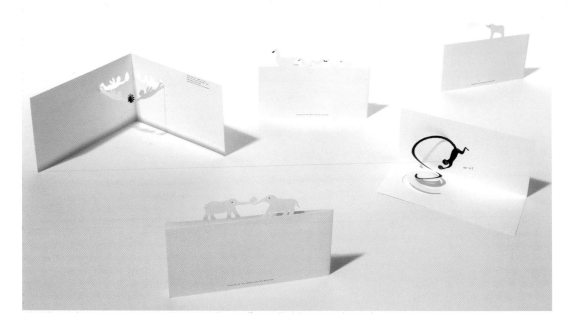

✱ see page 6
below
calendar
design agency: D-BROS
art director/designer:
Yoshie Watanabe
creative director:
Satoru Miyata

Numbers on this cute
calendar are illustrations of
things representative of the
month. For May, there are
springtime flowers, ducks,
and butterflies.

May 🌿

					1	2	3	4
s	m	t	w	t	f	s		
5	6	7	8	9	10	11		
12	13	14	15	16	17	18		
19	20	21	22	23	24	25		
26	27	28	29	30	31			

✳ see page 5
below
matchboxes
design agency/printer:
Graph
client: **Fukugura**
restaurant

✳ see page 5
right
menu cover
design agency/printer:
Graph
client: **Fukugura**
restaurant

Sake brewing company
Fukunishiki opened a
restaurant, Fukugura, in
a converted sake warehouse.
Graph created the branding
for the restaurant, even
down to the design of
these matchboxes.

Fukugura restaurant's
menu cover looks slick
and sophisticated with
its dramatic use of white
against black.

✱ see page 5
left + below
chopstick covers
design agency/printer:
Graph
client: Fukugura
restaurant

gallery 2 | 175

Chopstick holders are an
extra surface for showing off
the restaurant's design flair.

✱ see pages 13 and 99
exhibition
design agency: Hara
Design Institute/Nippon
Design Center
curator/catolog designer:
Kenya Hara

Graphic designer Kenya
Hara called upon the talents
of creatives from the fields of
architecture, product design,
lighting, and writing for the
exhibition *Re Design*, in
which established designs
were taken back to the
drawing board and remade.
The results made viewers
look at everyday objects in a
fresh light. The exhibition
toured internationally.

Exhibition catalog by Kenya Hara

Cockroach catcher by Kuma Kengo

Immigration stamp by Sato Masahiko

✱ see pages 13 and 99

exhibition
design agency: Hara
Design Institute/Nippon
Design Center
curator/catolog designer:
Kenya Hara

Here are shown further
inventive designs from
the *Re Design* exhibition.

Teabags by Fukasawa Naoto

Toilet roll by Ban Shigeru

Matches by Mende Kaoru

MATCHES FOR ANNIVERSARIES
FOR BIRTHDAY, FOR WEDDING
FOR SILVER WEDDING, FOR G
FOR ENGAGEMENT, FOR APPLI
FOR GRADUATION,
FOR COMING-ON-AGE
CEREMONY, FOR NEW YEAR,
FOR CHRISTMAS EVE,
FOR OLD BOYS ASSOCIATION,
FOR COMPLETION OF NEW HO
FOR A DAY OF GETTING NEW

below + right
visual identity
design agency: Hakuhodo
client: Regal
art director: Kazufumi
Nagai

The brand identity
for this high-quality
shoe shop includes a
sophisticated red and
black color scheme applied
to packaging, interiors,
and window displays.

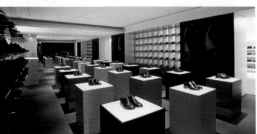

below
poster
design agency: Kenzo
Izutani Office Corp
client: IBM Japan

Why is the scene in this
poster so sad? Presumably
it's suggesting that IBM
products should be used
above other competitors'
products in order to avoid
the emotional grievance
brought on by lost data.

right
poster
design agency: Kenzo
Izutani Office Corp
client: Japan Graphic
Designers' Association
(JAGDA)

Produced on the fiftieth
anniversary of the atomic
bombings at Hiroshima and
Nagasaki, this was designed
for the *Peace and
Environment Poster
Exhibition* curated by the
Japan Graphic Designers'
Association (JAGDA).

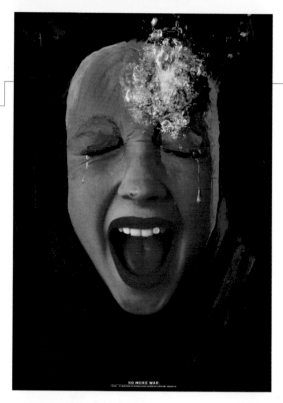

✱ see page 5
below
book design
Design agency: Graph
client: Amus Arts Press
art director:
Issay Kitagawa

The cover of the book *Kingyo*
(meaning "goldfish")
containing artist/graphic
designer Tanaami Keiichi's
works is vivid and loud.
According to designer
Kitagawa: "Emphasis was
placed on the design and
layout of the Japanese
and English fonts so that
they worked well with the
artist's work."

below
posters
design agency: Kenzo
Izutani Office Corp
client: AT&T Mail

The artwork for AT&T Mail
includes letters swiveling
out of the envelopes to
symbolize email as a form
of messaging free from the
confines of the traditional
postal services.

below
postcard
design agency: Ghost
Ranch Studio
client: 2001 Sexual Odyssey
designer: Yasutaka Kato

right
poster
design agency: Ghost
Ranch Studio
client: Sunto Office
designer: Yasutaka Kato

The unusual colors and
saucy subject of this
illustration makes for an
amusing take on what at
first glance appears to be a
traditional-style ornament.

A peculiar image... a militant
feminist accordian player
and a woman who's far
too old to carry around
a toy rabbit.

right **A.N.T. Girl character for Alien Noizy Tourist** far right **Sakura** illustrator: **Tokyo Alice**

Tokyo Alice creates cartoon-like illustrations that are filled with bright, Disney-esque technicolor and bold, lively strokes. The images shown here are kitsch and romantic, and include hints of Japanese traditionalism that appeal to the illustrator's international fans.

An odd partnership of
feminism and fairy-tales
pervades Tokyo Alice's work.
She typically perverts
traditional illustrative
scenarios with a modern,
punkish twist.

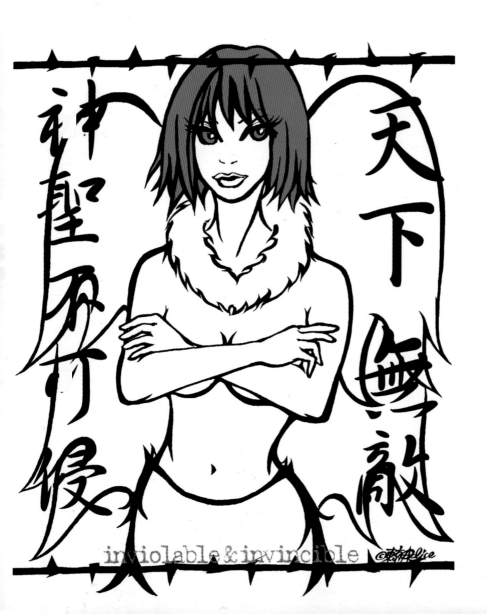

inviolable & invincible

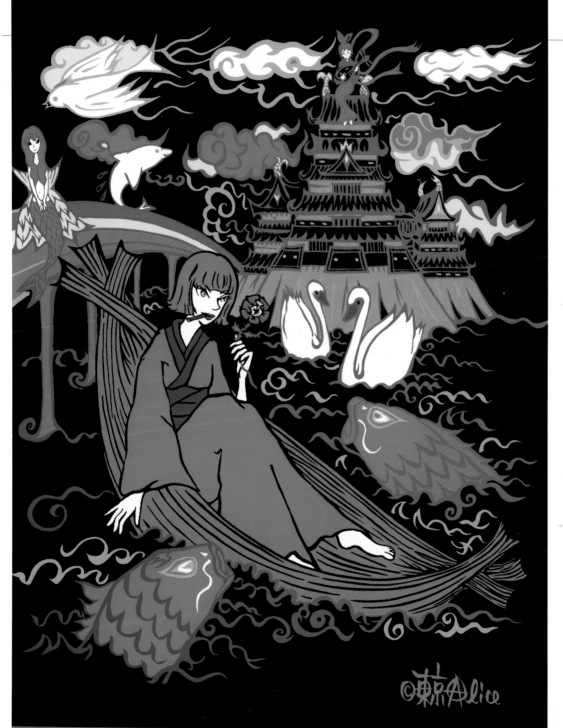

✱ see page 7
below + right
**TV commercials
and short film**
design agency: Uchu
Country Co. Ltd.
director: Nagi Noda

These images provide a
glimpse into the Japanese
fixation with cuteness:
almost every one features
a fluffy toy-like animal
character of some sort.

Suntory oo-long tea

Gekkeikan sake

Suntory Caffe Latte bottled coffee

Franc Franc—small love story

Design/illustration collective
Enlightenment work *Digital
Paintings* is based on the
concept of trying to create
oil painting-like finishes
using digital techniques.
They explain: "The
photographic images taken
or chosen by us are captured
on computer, then we draw
on the captured images
using a finger tool in
Photoshop." The completed
images are outputted
directly on to canvases
using the specialized
printing technique of Giclée.

✱ see page 5
below
poster
design agency:
Butterfly Stroke Inc.
client: Parco
artwork: Takashi Murakami

✱ see page 5
right
exhibition artwork
design agency: Graph
client: Doraemon
design: Fujiko-pro/Issay
Kitagawa

The superflat world of
Takashi Murakami—
dominated by gnome-ish
mushrooms, *manga* eyes,
and Mickey Mouse ears—
makes an appearance in
this poster for lifestyle
retail store Parco.

Popular cartoon character
Doraemon had an exhibition
dedicated to him. This
artwork depicts Doraemon's
magic pocket (from which he
produces many magic tools)
as an eye looking up at the
character. The horizontal
Japanese text reads *The
Doraemon exhibition*
and the vertical reads
"I love Doraemon."

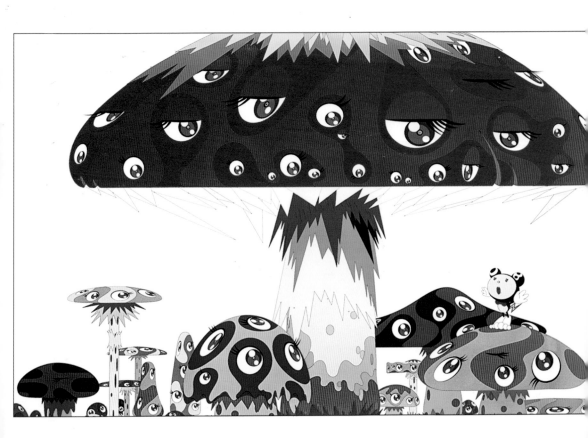

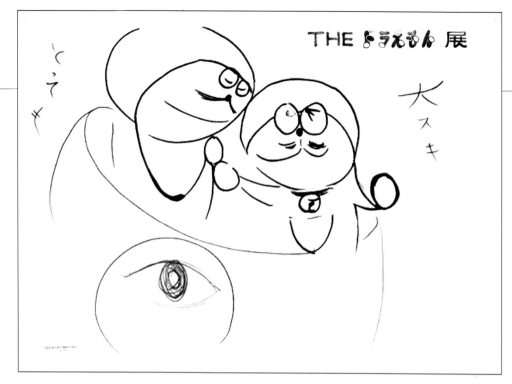

Jean-Pierre Khazem is renowned for shooting models wearing peculiar, larger-than-life masks in photographs, music videos, and advertisements. They've even appeared on fashion catwalks. Here, they seem to symbolize women putting on a mask before they hit the Venus Fort retail and leisure park. For Western readers, the "Japlish" text (see page 105) adds to the weirdness.

In this poster, the enormous eyes borrowed from the worlds of *manga* and *anime* appeals to an audience brought up on such motifs.

http://www.venusfort.co.jp

Let's go shopping
レッツ　　　　ゴー　　　　　ショッピング
To VenusFort
トゥ　　　　　ヴィーナスフォート
By
バイ
Driving or Yurikamom
ドライビング　　　オア　　　　　ユリカモメ
VenusFort Bargain

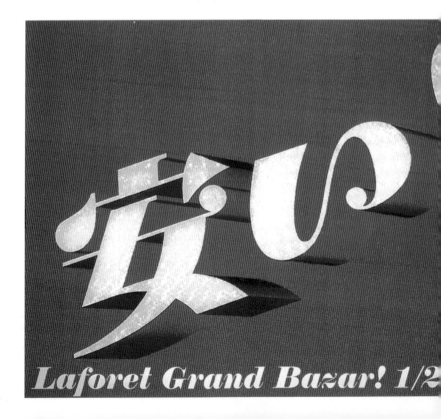

Laforet Grand Bazar! 1/2

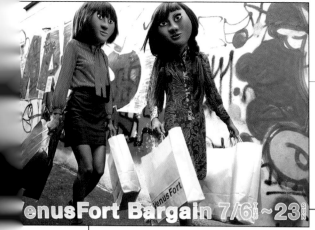

VenusFort Bargain 7/6日~23日

VenusFort is
ヴィーナスフォート イズ

One-year-old.
ワン イヤー オールド

Ladys are very happy
レディース アー ベリー ハッピー

With delicious cake.
ウィズ デリシャス ケーキ

VenusFort Birthday

25

✱ see page 5
bottom left **logo**
design agency: Butterfly
Stroke Inc.
client: Hiromichi Nakano
Design Office
creative director:
Hiromichi Nakano
art director/designer:
Katsunori Aoki
illustrator: Seijiro Kubo

✱ see page 5
below **poster**
design agency: Butterfly
Stroke Inc.
client: axev inc.
art direction/designer:
Katsunori Aoki
computer design:
Noriyasu Satou
illustrator: Bunpei Yorifuji

✱ see page 5
bottom right **logo**
design agency: Butterfly
Stroke Inc.
client: Inpaku
art director/designer:
Katsunori Aoki

Mickey Mouse-style ears
feature in this cheerful
logo for fashion designer
Hiromichi Nakano.

This cosy scene is for a
company whose name means
"MARM = Mom + Warm."

This logo is created from
bold, straight-edged
katakana, about which
buzzes a glowing red-nosed
character. Is it a bee? Is it
an aeroplane? Perhaps it's
a friendly little alien.

✱ see page 5
bottom right + left logo
design agency: Butterfly
Stroke Inc.
client: Mate Sha Inc
art director/designer:
Katsunori Aoki
illustrators: Bunpei
Yorifuji/Takuya Shibata

✱ see page 5
below logo
design agency: Butterfly
Stroke Inc.
client: Nihon Eiga Satellite
Broadcasting Corp.
art director/designer:
Katsunori Aoki

This logo is a drawing of
a potato-shaped man with
features made from hand-
drawn Japanese text.

These cute logos are for a
satellite television channel.

✱ see pages 5 and 6
below
annual
design agency:
Butterfly Stroke Inc.
client: Reiko Kojima
art director: Katsunori Aoki
creative director:
Masao Oshima
computer graphics:
Ichiro Tanida
creator: Kensho Yoshitani
illustrators: Seijiro
Kubo/Enlightenment

This annual, produced for
the Tokyo Copy Writers'
Club, features a girl with an
oversized head and a puppy:
cute verging on the sinister.

✱ see page 6
right
exhibition piece
client: Mosslight
illustrator: Enlightenment

More from the twisted world
of cute: Bambi poses in
a neck scarf and pearls.
The image was created for
an exhibition created in
collaboration with Mosslight,
a Japanese clothing and
accessories brand.

✱ see page 5
below + right
advertisements
design agency: Butterfly
Stroke Inc.
client: Sony Marketing
art director: Katsunori Aoki

Here, cute comes with right
angles and teeth.

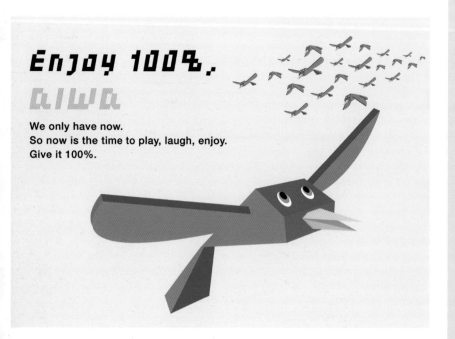

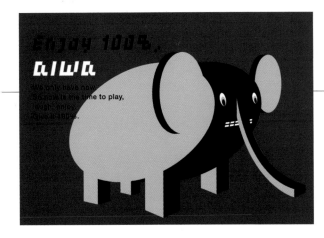

below
poster
design agency: Zuan Club
client: Amaguri Taro
designer: Akihiko
Tsukamoto

below
CD cover
designer: Noriyuki Tanaka
client: MOMO

This design may not
instantly make you lick your
lips, but it is for the
advertising of a brand of
candies made from
chestnuts—a popular
delicacy in Japan.

A super-cute teddy bear with
typically *kawaii*-style
oversized feet appears on a
CD cover for the band MOMO.

below
CD cover
design agency: Ghost
Ranch Studio
client: Ki/oon Sony Records

right
poster
design agency: Zuan Club
client: Condomania Tokyo
designer: Akihiko
Tsukamoto
illustrator: Radical Suzuki

Huge eyes and doll-like
innocence appear on
the illustration for this
album cover.

Here, a deadly serious pro-
safe sex/AIDS awareness
message is tackled in a
typically coy Japanese
way. The enormous eyes,
button nose, and glowing
blush of this cartoonish
girl is a world away from
the shock tactics often used
in similar advertisements
in the West.

✱ see page 211
left + below
**marketing
campaign
conducted by:
All Nippon
Airways (ANA)
original creator:
Satoshi Tajiri**

ANA reported an increase in
the number of passengers as
a result of decorating the
exterior of three Boeing 747s
with Pokémon. Food trays,
cups, and headrests were all
decorated with this
character from the Nintendo
Game Boy phenomenon.

© Nintendo•Creatures•GAME
FREAK•TV Tokyo•ShoProJR
Kikaku © Pokémon

kawaii:
the culture of the cute

kawaii:
the culture of the cute

Kawaii (pronounced kay-wah-ee), meaning "cute," must be one of the most loved and most widely used words in Japan. *Kawaii* essentially means "childlike," and, according to academic Sharon Kinsella, who has studied the phenomenon, it celebrates all that is: "sweet, adorable, innocent, pure, simple, genuine, gentle, vulnerable, weak, and inexperienced in social behavior and physical appearance." [1]

Kawaii culture manifests itself in the cute cartoon characters that infiltrate every part of life in Japan. As design writer Mary Roach explains in an article in *Wired* magazine: "[The Japanese] save money with cute (Miffy the rabbit on Asahi Bank ATM cards), pray with cute (Hello Kitty charm bags at Shinto shrines), have sex with cute (prophylactics decorated with Monkichi the monkey, a condom stretched over his body, entreating, 'Would you protect me?')." [2]

A love of cute characters appears to transcend both age and gender. Thirty-year-old women wake up to toasters that burn Hello Kitty's face onto a piece of bread, organize their lives with Hello Kitty day-planners, and wear Hello Kitty underwear. Some even own the infamous Hello Kitty vibrator. At rush hour you will spot many a suited "salaryman" head down, playing games, or laboriously texting friends, with Doraemon the robot or Afro-Ken hanging as charms from their cell phones (although talking on cell phones is forbidden on many trains, you hardly ever see Japanese people walking around talking on their phone—they're far too private for that).

When Mitsubishi launched a Snoopy car (no doubt a rival to Daihatsu's Hello Kitty car, which was pink and covered with pictures of the cat), their press release read: "Mitsubishi Motors wanted to introduce onto the market a model that would be [...] affectionately received by women in their twenties and thirties in particular, in order to cultivate Pajero Mini as a brand that enjoys long-lasting owner affection." [3]

Mitsubishi, which made 1,200 of these cars and put them on display in Snoopy Town shops, explained that, in Japan, the main customer group for both Snoopy and Pajero Mini are women in their twenties and thirties.

As well as cute cars, there have even been cute airlines. In June 1999, ANA (All Nippon Airways) decorated the exterior of three Boeing 747s with 20-foot-high Pocket Monsters from Pokémon, the Nintendo Game Boy phenomenon (✱ see pages 206–207). The airline reported an increase in the number of passengers as a result and the painting of planes is ongoing.

not just eye candy: the functions of cute

Cute is not just eye candy on the surfaces of consumer products; *kawaii* characters also function as a polite way of conferring guidance and information to the public. They appear on street signs, in instruction manuals, in phone books, and on utilities bills. Warning signs on automatic doors show startled bunny rabbits. Train ticket machines display cartoon staff bowing and thanking you for your purchase. If a road is being dug up, you can expect to see flyers showing cartoon moles wearing hard hats apologizing for the inconvenience. Tokyo Electric Power prints flyers feature "Little Miss Electricity," a pony-tailed cartoon housewife encouraging people to save power. In a country where people are brought up on a diet of *manga* and *anime*, cartoons are a common language.

Almost every public institution has a cute mascot. Japan's public broadcast channel, NHK, features a rather scary-looking, brown, square-shaped character with triangular teeth called Domo-kun, who has a best friend called Usaji ("Old Man Rabbit") who wears glasses and always carries a cup of green tea. Each police department of Japan's 47 prefectures has a distinctly un-macho mascot. Tokyo's police department has a giant animated mouse with a pointy blue hat called Pi-Po Kun, so-named because "pipo pipo" is the noise that police sirens make and because the word is a compound

of the Japanese words for "people" and "police." Kanagawa police department's mascot is a yellow seagull, Pi-Gull, because there is a large port in the department. Hyogo police has Kohei-Kun, a stork with enormous pie eyes wearing a police cap. Even Japan's Defense Agency uses a battery of baby-faced cartoon soldiers.

kawaii and the cute face of corporate

For corporate business, *kawaii* helps to give a friendly face to an otherwise impersonal corporate identity, giving people a way to build a personal relationship with a particular brand.

Miki Kato, writing in graphic design magazine *Eye*, explains that the fondness for *kawaii* culture could stem from the Japanese habit of self-deprecation:

"Japanese tend to enjoy funny topics for daily conversation, such as 'what kind of dumb things they've done,' or descriptions of their own mistakes. This is an attempt to disarm the listener, and to develop more intimate relationships. Similarly, funny mascots tell you that the owner is friendly and unpretentious." [4] Companies employ the same tactics as individuals: they make themselves more approachable and less threatening by adopting cute mascots.

The use of dolls as mascots in Japanese culture is deep-rooted. The samurai carried amulets (omamori) for protection. During the Asia-Pacific war (1931–45), thousands of women made dolls, mostly from scraps of kimono, for men serving in the army and navy, which were worn by the men on cords around their necks or hanging from their hips. This appears to be an example of the widespread belief in Japan that dolls have a kind of soul (tamashi) and can carry the identity or essence of the person who has made or owned them.

The widespread use of kawaii is a fairly recent phenomenon, however. Sharon Kinsella, in her essay "Cuties in Japan," explains that the word kawaii is derived from kawajushi, a word that first appeared in dictionaries prior to 1945. It had principal meanings of "shy" or "embarrassed," but possessed secondary meanings such as "pathetic," "vulnerable," "darling," "loveable," and "small." Kawaii first appeared in the early 1970s, at the same time as the emergence of a new craze among teenagers, especially girls, for cute, babyish handwriting. "Previous Japanese writing had been written vertically using strokes that vary in thickness along their length," explains Kinsella. "The new style was written laterally, preferably using a mechanical pencil to produce very fine even lines. Using extremely stylised, rounded characters with English, katakana [see page 96] and little cartoon pictures such as hearts, stars and faces randomly inserted into the text, the new style of handwriting was distinct and the characters difficult to read." [5]

The writing, which had names such as marui hi (round writing), koneko ji (kitten writing), and manga ji (comic writing), liberally used exclamation marks and was punctuated with affectionate words such as "love" and "friend." The abundance of English words and the romanized left-to-right direction of the script leads Kinsella to believe that young people were rebelling against traditional Japanese culture and identifying with European culture, which, she says, they "obviously imagined to be more fun." [6] The style was no fleeting fad. It grew and grew, and by the mid-1980s, millions of kids throughout Japan were using it. This caused discipline problems in schools. Some schools banned the writing entirely or refused to correct tests with answers written in the style.

As the handwriting craze developed, so did a fashion among young adults for childish behavior, baby-talk, and wearing childish clothes. Kinsella explains:

"Young people who dressed themselves up as innocent babes in the woods in cute styles were known as burikko (fake-children). [This] spawned a verb, burikko suru (to fake-child-it), or simply buri buri suru (to fake-it)." [7]

Dressing up continues to be practiced by Japanese youth, notably by the otaku kids (and sometimes adults)—the obsessive fans of manga and anime, who dress up as their favorite cartoon characters. This tends to have derogatory connotations in Japan and is not practiced by everyone who adores kawaii.

kawaii and worship of the childlike

Miki Kato adds further light on *kawaii* culture's origins by explaining how childlike behavior is inherent in the Japanese character. An important word in Japanese is *amae*, which means to "act like a child." She explains:

"If you invite a Japanese acquaintance to dinner, and ask them what kind of restaurant they would like to go to, they will probably answer, 'anywhere you like.' Not having an individual voice is considered a traditional virtue in Japan and this is based on the idea of *amae*." [8]

In Japan, group harmony is valued above individual expression. The terms *tatemae* and *honne* describe types of social behavior that are the cornerstones of social harmony. The *tatemae* is the face that one shows to society; the *honne* is one's true heart—one that has to be hidden for the sake of maintaining social equilibrium. It is an unspoken way of behaving, in public and in the workplace.

Kawaii gives people a way to hang onto childhood and thereby postpone the pressures of adulthood. Kinsella explains:

"The idea underlying cute was that young people that had passed through childhood and entered adult life had been forced to cover up their real selves and hide their emotions under a layer of artifice. Ironically, it is cute that is in fact extremely artificial and stylised. Adulthood was not viewed as a source of freedom and independence, it was viewed as quite the opposite, as a period of restrictions and hard work. [...] cute fashions idolise childhood because it is seen as a place of individual freedom unattainable in society." [9]

For instance, because living space is at a premium in Japan and property expensive, many Japanese people live with their parents well into their thirties. The workplace tends to be tough, with long hours and unquestioning loyalty expected of employees. Whereas once it was frowned upon for a woman to be single after the age of 25, women now try to defer marriage as long as possible because they see it as a time when they give up their independent incomes and disappear into the suburbs to bring up children.

In the West, adolescents seek release from childhood by rebelling against its constraints, while adults reminisce about the wildness of youth. The Japanese reminisce about childhood and, for the current generation of young Japanese people brought up with the fashionable cult of fake-childing-it, actual childlike behavior is quite acceptable.

identity and belonging through kawaii

Both Kinsella and Kato believe that creating quasi-relationships with cute, inanimate objects is a relief from, or compensation for, the alienation that many people feel. Kinsella writes:

"Modern consumers might not be able to meet and develop relationships enough with people, but the implication of cute goods design was that they could always attempt to develop them with cute objects." [10]

A perfect example of this is the Tamagotchi, the virtual pets that require their owner to attend to their feeding, playing, and sleeping, and that die if they do not receive appropriate care. These toys beep their owners when they need attention. They demand a lot of time and energy, but they make their owners feel needed.

Many people believe that they can find a cute character or mascot tailored to their personality. There are thousands to choose from and each has seasonal variety. People adopt a character as a means of seeking their own identity, while also gaining entry to a group. Kato says:

"Wearing a cute mascot in public is a way to communicate with others like yourself. There is a consensus that a person who likes cute things is good. If you show a funny mascot, people assume that you are an easy-going and open-minded person. Your mascot makes people around you believe you are more approachable.

The mascot also affects you: it gives you a sense of membership in the group that likes and identifies with that character."[11]

The Japanese are not alone in seeking identity through inanimate, mass-produced objects: it happens in all capitalist societies. In the West, young people express their personal taste while feeling part of a group by wearing a certain type of trainers or a certain brand's logo on their t-shirt. But in the West, the relationship with these brands is slightly different. An Adidas logo isn't adored and personified in the same way as a picture of Hello Kitty is. And, even though the West generates many of its own cute characters (Walt Disney characters, Winnie the Pooh, Brambley Hedge, Wallace and Gromit, and so on), the biggest license market is Japan and the Japanese audience of adults as well as children. Western adults have little interest in these characters. According to an estimate by United Media, the Peanuts character merchandise forms a market of US$1.2 billion worldwide: 40 percent in Japan; 35 percent in the US; 12 percent in the EU; ten percent in Asia; and three percent in other countries.

Today, character licensing is big business. In some cases, the license component of a movie, television show, *manga* comic, or *anime* has a huge impact on profit. In Hollywood, for example, a production company knows that it may make a couple of million dollars from a movie, but that it will make hundreds of million dollars from the licensing. In Japan, the same is true. One difference in Japan, however, is that there are thousands of successful cute characters that have no movies, television series, comics, or animations to back them up. In the West, the majority of characters are only licensed out once they have been developed in media elsewhere and their popularity has been proven. In Japan, many characters exist for years simply as decorative pictures on merchandise.

The undisputed queen of merchandise cute is Hello Kitty, who first appeared on a plastic purse in 1975. The animated cat, who lives with her parents George and Mary White and twin sister Mimi, in London, England, and who loves to spend time with her friends, bake, and collect hair ribbons, has since found her way into nearly every Japanese home. As well as decorating numerous consumer products, Kitty has made records, acted as Junior Ambassador to UNICEF, appeared in the animated television series *Daisuki! Hello Kitty*, and has starred in several movies and

comic books. She has her own fan club and is constantly inundated with fan mail. Hello Kitty is now world-famous and is a billion-dollar industry for Sanrio, the company behind her.

Sanrio, Japan's equivalent of Hallmark cards, is the largest and most well-known company creating such characters. It was the first company to start capitalizing on *kawaii* style generated by the cute handwriting craze, and has been capitalizing on it (perhaps even perpetuating it) ever since. First of all, it began to print dreamy, decorative designs on their previously plain writing paper, borrowing motifs that had become so popular among young people, such as pastel colors, hearts, flowers, and cute little animals. Such stationery proved extremely successful, and Sanrio expanded this style to other *fanshi guzzu* (fancy goods). Cute cuddly toys, toiletries, lunch boxes, and towels were sold in specialist cute shops.

Soon Sanrio invented whole casts of cute little characters, with names such as Button Nose, Tiny Poem, Duckydoo, Little Twin Stars, Cheery Chums, Vanilla Bean, and Tuxedo Sam, to endorse and give life to merchandise. First these characters existed only on products sold in cute shops. Now Sanrio even runs theme parks where millions of visitors come every year to ride on cute rides and watch the characters perform in live shows.

It wasn't long before Sanrio's characters were working hard selling, under license, the goods and services of hundreds of Japanese companies.

Today, character licensing is a trillion-yen industry. Many Japanese companies prefer to license a well-known character as the face of their brand. This seems unusual—surely it would be better for them to create and build their own unique character? Some companies do. For many years, Japanese kids have been familiar with Peko-chan, a cute girl character who adorns the packaging of major confectioner Fuyiya Co. A recent character phenomenon is the Nova Rabbit, a cute pink rabbit character introduced by a chain of foreign language schools. Initially, Nova started selling the rabbit as dolls to new students, but soon began selling them in the classrooms to other students.

"It requires courage for students to visit language classrooms and the dolls make it easier for a prospective students," [12] said a Nova official. The rabbit has now taken on a life of its own beyond the classroom: in July 2003, within ten months of its introduction, Nova had concluded license contracts for the character with eight companies, including clothing manufacturers.

These are success stories, but, for every successful character, there are hundreds more that struggle and eventually fail.

Creating a brand through a character and building it from scratch takes a lot of commitment, planning, and investment, and possibly years of effort to achieve any kind of recognition. According to industry insiders, once the character has made its debut it is difficult for it to remain popular for more than two years, and after that it can even be bad for the company's image.

Unlike most American characters, whose use and design is tightly controlled, Hello Kitty and friends manage to keep Japanese fans hooked by changing constantly. Each year, the designers come up with a new theme for Kitty—she's all in plaid one year, and in pink another. She's even been black and white. She has been a tiara-wearing princess and she's been Robo Kitty, sporting a robot body and wearing a helmet just like Robo Cop.

When it comes to using characters, many Japanese companies think it is wiser to piggy-back the popularity of existing characters. Once the character ceases to work for the company, it can easily be scrapped or a new variation of the character adopted. Most characters are generated in-house at companies like Sanrio, San-X, and Super Planning Company. They are then licensed at big annual events like License Asia, where hundreds of domestic and international licensors meet to display their characters. Animated characters are ideal because they can convey the company however the company wishes and, when used in television commercials, are much cheaper than using a television personality (which was very popular at one time).

graphic design and character licensing

Increasingly, graphic design agencies, such as Furi Furi and Butterfly Stroke Inc. (✿ see pages 18–25, ✳ 194, ✳ 196–200, and ✳ 202–203), are attending licensing events, seeking to capitalize on the popularity and profitability of character design. Groovisions is a graphic design agency whose characters have become a much-loved phenomenon in Japan. Their flatly rendered "chappies" grace mousepads, calendars, t-shirts, packaging tape, and album covers.

Graphic design agencies that attend such events may have great products, but it's not clear whether this is sustainable for all design agencies. As Kim's Licensing (licensors of the popular characters Tarepanda and Pucca) says:

"Many designers and companies, despite the fact that they have developed and maintained outstanding properties, have often lost competitiveness and disappeared from the market because they did not know how to apply and utilize them. Even now, many character companies are getting consultations for the 'licensing' but more than 80 percent of character development or licensing companies are small-scaled and not professional enough." [13]

how graphic designers use cute

Most Japanese graphic designers, whether they create their own characters or not, will incorporate elements of the visual language of cute into their work at some time or other. As cute is proven to sell products and promote services, this inclusion will often be at the insistence of clients.

Some visual features are borrowed from the world of cute merchandise characters, while others borrow from *anime* and *manga*. Cute animals such as rabbits, kittens, and pandas are often adopted. Characters are usually small, soft-looking, pastel, and round—often pot-bellied. They usually lack limbs or have extremely small, swollen, and stumpy ones, lacking fingers or toes. If characters have feet at all, they will be pigeon-toed to enhance their look of helplessness. They lack bodily orifices, so are mute and asexual. Their heads will be huge and their eyes simple dots or slits to make them look either shocked or peaceful, sleeping, sleepy, or blind. Tarepanda (meaning "lazy panda") is a sloth-like sandbag of a bear, constantly sleeping, constantly needing to be looked out for. Miffy has dot eyes and a cross for a mouth. Hello Kitty doesn't have a mouth at all.

In the FAQs on Sanrio's website there's the question: "Why doesn't Hello Kitty have a mouth?" The company's answer is "Hello Kitty speaks from the heart. She is the ambassador to the world and doesn't speak 'one' language." [14]

Now, Hello Kitty has gone one step further and even discarded her body. In an article for *Wired*, Mary Roach writes: "If a character needs to do nothing more than increase the appeal of a hair clip or wallet, it has no need for legs or neck or anything to dilute the basic elements of cute: round, little, simple, lovable. The current look of Hello Kitty merchandise takes this basic formula a step further, reducing the feline to a bow-bedecked head." [15] Kazuo Tohmatsu, Sanrio's General Affairs Manager explained to Roach: "What's happening is, it's becoming more of a logo." [16]

Where some features are minimal, others are enormous. Large ears are popular, particularly rabbit ears, and if eyes aren't simple dots or lines, they will be enormous pie eyes —a style borrowed from *manga* and *anime*. Such eyes are normally set apart, with the iris made to look as though there is a huge light shining upon it. Large eyes are considered to be appealing because they hide no emotion and display innocence and an unthreatening cuteness.

the influence of anime and manga

The phenomenon of enormous eyes emerged in Japanese comics during the time of the Allied Occupation from 1945 to 1951, when Disney comics and animated films were sold and distributed throughout the country (see page 111). Before the Japanese came into conflict with Westerners, they depicted themselves with Asian features, and often with smaller-than-life eyes in scroll painting and woodblock prints. Now the exaggerated round eyes and distorted physical features of early Western comics seem more Japanese than American in style because of their entrenchment in the graphic traditions of *anime* and *manga*. Fred Schodt, in his book *Manga! Manga!*, explains that:

"Children, especially, seem to be attracted to cartoon characters with big eyes, and in Japan young girls complain if artists draw them smaller." [17] He explains how the emergence of these eyes changed the way Japanese people wished to view themselves:

"Round eyes, as opposed to the graceful, simply curved Asian eyes with their epicanthic fold, have become a sought-after commodity because they are regarded as more expressive." [18] It has been popular for women to have plastic surgery to create rounder eyes. Clear adhesive tape has been sold to create a similar, albeit temporary, effect.

Other common characteristics of *anime* and *manga*, sometimes borrowed by graphic designers, include colored, particularly green, hair, cat or antenna-like ears, tails, bells, school uniforms, characters dressed in housemaid and babes-in-the-wood outfits, and over-sized hands and feet... features that might be interpreted as grotesque by many Westerners.

will kawaii ever lose its appeal?

So, is there any sign of the *kawaii* craze abating? In some quarters, yes. Since the early 1980s, most banks were associated with a cute cartoon character, plastering them on ATM cards, in advertising and on give-away mugs, plates, and other goods. Post-millennium, and things started to change: banks began to become more serious.

Sanwa Bank and Tokai Bank had long been affiliated with Snoopy and Bugs Bunny, but when the two merged into "megabank" UFJ Bank Ltd., in 2002, the characters were "retired." In place of the dog and the rabbit, the UFJ Group chose a solid-looking ring for its new logo, explaining:

"The ring design is a straightforward expression of the high-quality services promised to our customers, strong confidence of our customers, and the image of steady growth with our customers." [19]

Dai-Ichi Kangyo Bank's Hello Kitty, Fuji Bank's duck mascot and Industrial Bank of Japan's Kewpie were all relegated to the sidelines when the three merged within Mizuho Holdings Inc. The megabank chose a "simple yet sophisticated logotype" of the Mizuho name in blue, underscored by "a striking red arc" [20] representing the sun rising over the horizon.

In 2003, Asahi Bank ditched Miffy before merging with Daiwa bank to create Resona Bank ltd. The Resona logo is described as "two Rs inside a perfect circle to

express a sense of security and trust [expressing] our desire to build stronger ties with customers by 'resonating' or 'resounding' with them." [21] The company hasn't disowned cute entirely: it has a new cast of cartoon characters created by the animation firm Studio Ghibli, creators of the Oscar-winning *Spirited Away* (2001), Japan's highest-grossing movie ever. This new ad campaign features a portly 28-year-old Resona banker and his family.

Many of these banks have had to work on their images because they developed a bad reputation throughout the recent recession years. Many had run up trillions of yen of bad loans to corporate borrowers and they are now eager to project a more sober image to the public. Ditching characters is also a good cost-cutting exercise, enabling enormous savings in license fees.

Mergers and image changes are also often signs that banks wish to create more of a presence on the global stage. As trade barriers continue to come down across the world, the rules of survival have changed. In some instances, domestic markets have become too small. To survive, companies need to find and dominate new markets, making it imperative for companies to project global brands. Ditching domestic cute and replacing it with a more conservative visual emblem could be a way of gaining global acceptance. Nonetheless, there are other companies who are still using *kawaii*. At the time of writing, ANA is in the middle of painting a new jet's fuselage with Pokémon characters, which will be landing in LA.

conclusion

The world is developing a taste for Japan's popular visual culture. *Manga* and *anime* is increasing in popularity day by day. After its introduction in the US in 1998, Pokémon generated US$700 million in retail sales the following year. Today, Pokémon reaches schoolkids in more than 65 countries, and 60 percent of the world's animated cartoon series are made in Japan. Games running on PlayStation 2 and (to a lesser degree) Nintendo's Game Cube rule the video-game universe just as strongly as before, despite an attack from Microsoft's Xbox. There are *otaku* conventions throughout the United States and Europe, attended by kids in their thousands, almost rivaling in size the ones in Japan. More and more young people are choosing to learn Japanese. And, today there are 4,000 Sanrio speciality shops in the United States alone.

Some observers even suggest that with its unique ability to accept, synthesize, and spin a host of foreign influences into something both global and local, Japan is the favorite to become the world's next cultural superpower. The main instigator of this idea is American writer Douglas McGray, who argues that Japan's cultural output is so successful because it is broad and deep, but also approachable. Using Hello Kitty as an example, he writes:

"Hello Kitty is Western, so she will sell in Japan. She is Japanese, so she will sell in the West.

It is a marketing boomerang that firms like Sanrio, Sony and Nintendo manage effortlessly. And it is part of the genius behind Japanese cultural strength in the global era." [22]

McGray cites Marubeni Research Institute's findings that, between 1992 and 2002, royalties from Japan's cultural exports tripled to $12.5 billion—a staggering growth rate in modern-day Japan. So, even though Japan's days as an industrial powerhouse may well be on the wane, its role as global trendsetter is fast emerging.

Recession, which started in the early 1990s, seriously shook Japan's confidence. For the first time, in a country where once everyone could expect a job for life, suddenly there was unemployment and many people were forced into dead-end, part-time work. For the young, Big Business was discredited as the traditional career path. Out of this situation, however, entrepreneurialism began to emerge. Suddenly, individualism and risk-taking began to seem attractive. McGray quotes a London School of Economics-sponsored study found that young Japanese people have been more motivated to start new businesses rather than opting to work in large, established companies or in the public sector. Many of these corporate refugees are founding their own movie-production companies, boutique advertising firms, DJ collectives, fashion-design studios, art

galleries, and any number of risky ventures that fuel, and eventually monetize, what Douglas McGray describes as "the cool." McGray quotes Ichiya Nakamura, a visiting scholar at Stanford Japan Center and M.I.T. Media Lab:

"This is the period of change from the postwar generation who supported the manufacturing Japan to the younger generation who will be building the cultural Japan." [23]

So, there may not be the huge budgets and jobs for life that there once were, but there is plenty of scope for invention and creativity. All these creative upstarts will surely breathe new life into the graphic design industry. And perhaps even the experimentation of established graphic designers in new areas of design, as discussed in the opening pages of this book, is a sign that this spirit of entrepreneurialism, rebellion, and creative confidence is infectious.

1 Sharon Kinsella (1996) "Cuties in Japan." In: Lise Skov and
 Brian Moeran (Eds) *Women, Media and Consumption in
 Japan*. University of Hawaii Press.
2 Mary Roach "Cute Inc." *Wired* issue 7 12 December 1999.
3 Press release from Mitsubishi Motors, 16 March 2000,
 Tokyo.[http://media.mitsubishimotors.com/pressrelease/e/
 products/detail 489.html]
4 Miki Kato "Cute Culture." *Eye* issue 44 summer 2002.
5 Kinsella, *ibid*.
6 *ibid*.
7 *ibid*.
8 Kato, *ibid*.
9 Kinsella, *ibid*.
10 Kinsella, *ibid*.
11 Kato, *ibid*.
12 Roach, *ibid*.
13 www.kimslicensing.com/english/
14 www.sanrio.com
15 Roach, *ibid*.
16 Roach, *ibid*.
17 Fred Schodt (1986) *Manga! Manga! The World of Japanese
 Comics*. Kodansha.
18 *ibid*.
19 Natsuo Nishio "Snoopy, Bugs shown the door as Japanese
 banks get tough." *The Dow Jones Newswires* 20
 February 2003.
20 *ibid*.

21 www.resona-hd.co.jp/e-ir/pdf/i_03b/ar_p2_3.pdf
22 Douglas McGray, "Japan's Gross National Cool." *Foreign
 Policy* May 2002.
23 *ibid*.

index

contributors

Barnbrook Design
www.barnbrookdesign.co.uk
Virus@easynet.co.uk

Butterfly Stroke Inc.
www.butterfly-stroke.com
Fax: +81 3 5541 0085

Curiosity
www.curiosity.co.jp
info@curiosity.co.jp

Dainippon Type Organization
http://dainippon.type.org
dainippon@type.org

D-BROS
Fax: +81 3 3498 5377

Enlightenment
www.elm-art.com/
ss@elm-art.com

Enterprise IG Japan K.K.
Fax: +81 3 5791 8501

Ghost Ranch Studio
Fax: +81 3 3788 0635

Graph
www.moshi-moshi.jp/
graph@moshi-moshi.jp

Hakuhodo
www.hakuhodo.co.jp
Fax: +81 3 5446 4466

Hara Design Institute/Nippon
Design Center Inc.
www.ndc.co.jp
Fax: +81 3 3564 9445

Hideki Nakajima
Nakajima Design
www.nkjm-d.com
Fax: +81 3 5489 1758

Hiromura Design Office
Fax: +81 3 3409 5562

Kenzo Izutani Design Corp
Fax: +81 3 3701 7535

Landor
Fax: +81 3 3263 2292
www.landor.com/tokyo

Ken Miki & Associates
office@ken-miki.net

www.ken-miki.net
Nagi Noda
Uchu Country
mailinfo@uchu-country.com

Nomade
Yumi Morimoto/Toshio Shiratani
y-cb@tkb.att.ne.jp

Akio Okumura
www.okumura-akio.com/
oku@okumura-akio.com

Pentagram
www.pentagram.com
email@pentagram.co.uk

Noriyuki Tanaka Activity
nt-act@mtb.biglobe.ne.jp

Tokyo Alice
www.tokyoalice.com
alice@illustar.com

Akihiko Tsukamoto
Zuan Club
zuan@big.or.jp

acknowledgments

Many thanks to all the designers who contributed images to this book. A huge thank-you to Rico Komanaya for all her time and patience spent chasing images and translating, and to Tokyo design writer Ayako Ishida for taking time to show me around her favorite Tokyo haunts. To Leonie Taylor and Nicola Hodgson my editors—thanks for giving me the space I needed, and thanks to April and Aidan for giving me this opportunity. Well done to Violetta and Luke for the lovely design of this book.

contributors

Barnbrook Design
www.barnbrookdesign.co.uk
Virus@easynet.co.uk

Butterfly Stroke Inc.
www.butterfly-stroke.com
Fax: +81 3 5541 0085

Curiosity
www.curiosity.co.jp
info@curiosity.co.jp

Dainippon Type Organization
http://dainippon.type.org
dainippon@type.org

D-BROS
Fax: +81 3 3498 5377

Enlightenment
www.elm-art.com/
ss@elm-art.com

Enterprise IG Japan K.K.
Fax: +81 3 5791 8501

Ghost Ranch Studio
Fax: +81 3 3788 0635

Graph
www.moshi-moshi.jp/
graph@moshi-moshi.jp

Hakuhodo
www.hakuhodo.co.jp
Fax: +81 3 5446 4466

Hara Design Institute/Nippon
Design Center Inc.
www.ndc.co.jp
Fax: +81 3 3564 9445

Hideki Nakajima
Nakajima Design
www.nkjm-d.com
Fax: +81 3 5489 1758

Hiromura Design Office
Fax: +81 3 3409 5562

Kenzo Izutani Design Corp
Fax: +81 3 3701 7535

Landor
Fax: +81 3 3263 2292
www.landor.com/tokyo

Ken Miki & Associates
office@ken-miki.net

www.ken-miki.net
Nagi Noda
Uchu Country
mailinfo@uchu-country.com

Nomade
Yumi Morimoto/Toshio Shiratani
y-cb@tkb.att.ne.jp

Akio Okumura
www.okumura-akio.com/
oku@okumura-akio.com

Pentagram
www.pentagram.com
email@pentagram.co.uk

Noriyuki Tanaka Activity
nt-act@mtb.biglobe.ne.jp

Tokyo Alice
www.tokyoalice.com
alice@illustar.com

Akihiko Tsukamoto
Zuan Club
zuan@big.or.jp

acknowledgments

Many thanks to all the designers
who contributed images to this
book. A huge thank-you to Rico
Komanaya for all her time and
patience spent chasing images
and translating, and to Tokyo
design writer Ayako Ishida for
taking time to show me around
her favorite Tokyo haunts. To
Leonie Taylor and Nicola Hodgson
my editors—thanks for giving me
the space I needed, and thanks to
April and Aidan for giving me this
opportunity. Well done to Violetta
and Luke for the lovely design of
this book.